Collins

YOU CAN PAINT

Oils

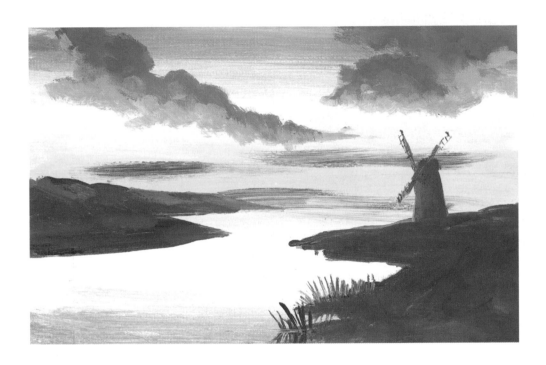

LINDA BIRCH writes regular articles for *Leisure Painter*
magazine, and is the author of *How to Draw and Paint
Animals* (David & Charles). She has taught painting
and drawing for the past 30 years in Adult Education
and has also illustrated over 150 children's books.

Collins

YOU CAN PAINT

Oils

A step-by-step guide for
ABSOLUTE BEGINNERS

LINDA BIRCH

First published in 2001 by
HarperCollins*Publishers*
77-85 Fulham Palace Road
Hammersmith
London W6 8JB

Collins is a registered trademark of
HarperCollins Publishers Limited

The Collins website address is
www.collins.co.uk

02 04 06 07 05 03
2 4 6 8 9 7 5 3

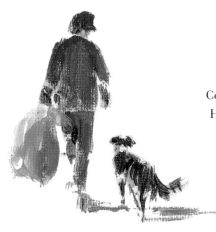

**A catalogue record of this book is available from the
British Library**

Editor: Isobel Smales
Designer: Penny Dawes
Photography: Syd Neville

ISBN 0 00 413408 7

Colour reproduction by Colourscan, Singapore
Printed and bound by Rotolito Lombarda SpA, Italy

Contents

INTRODUCTION

This book will help you to create your first oil paintings. You do not necessarily have to be talented or gifted in some way to be able to paint. Anyone can do it, provided they want to, and that they don't mind making mistakes occasionally. Making mistakes is part of the learning process. Exercises need to be done, and confidence has to be built. This book leads you through simple stages to making your first pictures, even if you have never painted before.

Oils are one of the most reassuring mediums. They are easy to put right if things go wrong – either you paint over your mistakes or you can just wipe everything off with a rag soaked in turpentine or white spirit.

You will not need lots of special equipment or a large range of colours to get started. There are some things you must have and these are listed on pages 8–11. For example, good brushes are important, but you only need three or four – look after them well, and they will last for years.

Naturally, when using tools or instruments, it is important to get to know them, to work out how they function, and to try them out to see what they can do. The stages in this book will enable you to do this. Above all, remember that the more you practise, the better you will be!

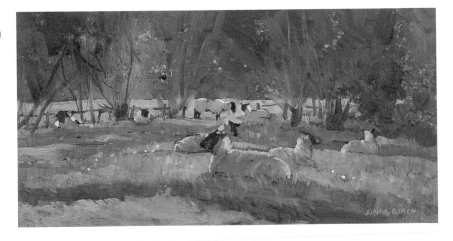

Summer afternoon
35 x 19 cm (14 x 7½ in)
Canvas

HOW TO USE THIS BOOK

This book is full of step-by-step exercises for you to follow, which will help you to progress into oil painting with confidence. If at any time an exercise does not work out for you, try it again, or go one step back to make sure that you have understood the previous exercise.

Once you have completed a stage in the book, try something similar for yourself. For example, after the painting of fruit, set a still life up yourself and paint it. Test everything out that you read in the book – is it true, does it work for you?

From time to time I have done demonstrations, which show you each stage that goes into making up a picture. You may find that colour mixing is one of the most difficult parts of painting. Don't worry if the colour mixes you make don't work out first time; like any skill, colour mixing needs a little practice to get things right. The more mixing you do, the more accurate your mixes will be.

There is a 'jargon buster' included on p.96 to help you to become familiar with the language and terms used in painting. Unfortunately, some teachers and some books will bewilder you with jargon – although you do need to know about some terms, the rest is really common sense.

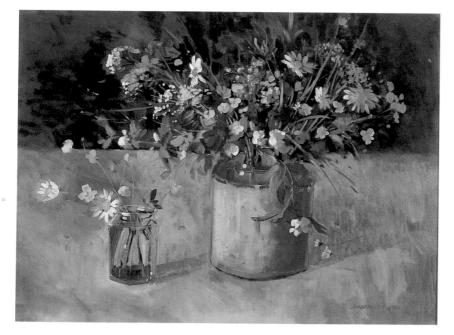

Summer flowers
74 x 61 cm (29 x 24 in)
Hardboard

Basic Materials

You won't need a vast amount of expensive equipment to start oil painting. Your local art materials store will sell various oil paints and brushes, and you will not need many colours or brushes to make a start. Your palette can be an old plate, and you can even paint on cardboard!

Colours Oils come in two different grades, students' and artists' colours. Students' are less expensive and are perfectly suitable for a beginner. Oils are sold in tubes of various sizes. I suggest that you buy the 22 ml size for all the colours except white, which you will need in a 115 ml tube. This is because you will need more white for mixing than the other colours.

The colours that I use in this book are:
- ✓ Titanium White
- ✓ Cadmium Yellow Pale
- Lemon Yellow
- Rose Madder
- Cadmium Red
- ✓ Crimson Alizarin
- ✓ French Ultramarine
- Coeruleum
- Cobalt Blue
- ✓ Viridian
- Burnt Umber
- ✓ Yellow Ochre
- Raw Sienna

To help you learn to mix your colours, I have kept to simple mixes in this book.

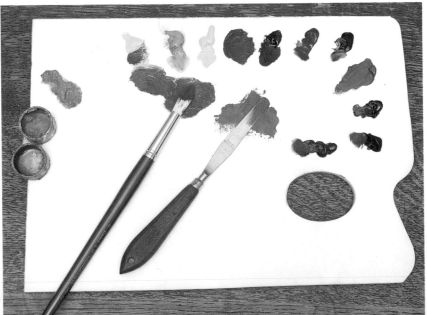

A palette of the colours used in this book

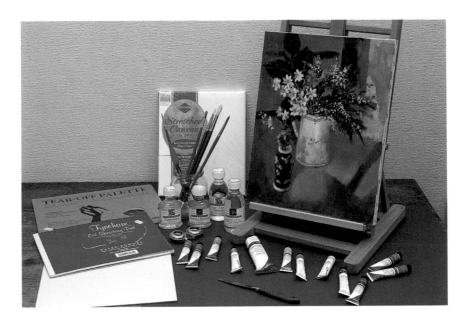

A selection of materials used for oil painting

Brushes Three brushes will usually suffice for most purposes. You will need a large (size 8) round-ended hog bristle brush, for large areas of paint such as skies. A medium-sized (size 6) square-ended hog bristle (known as a 'bright') is helpful for general work. I also use a small, soft nylon round brush (size 4) for detailed work and drawing out. The higher the number, the larger the brush.

Palette and painting knives Palette knives are long-bladed and round-ended. Originally used for mixing colours on the palette, they can be used to lay paint onto the picture instead of or as well as brushes.

Painting knives are small, trowel-shaped knives shaped especially for knife painting (impasto, where the paint is used thickly) or to be used in conjunction with brushes.

Palettes You must have a large area to mix your colours on. A simple palette could be an old dinner plate, or a large sheet of perspex or glass. Traditional wooden thumbhole palettes are available in various sizes, and need to be

'oiled in' before use (rubbed thoroughly with linseed oil to seal the surface to take oil paint).

Tear-off palettes (complete with thumbhole) consisting of leaves of vegetable parchment are useful, as the sheets can be torn off and disposed of leaving a fresh surface underneath.

Dippers These are small metal containers that clip onto the side of your palette. They contain your painting medium and, if a pair, a little cleaning medium such as turpentine. You could use a small tin jar lid.

Cleaning jar You will need a jam jar with a lid to hold white spirit or turpentine to wash your brushes. Leave the dirty white spirit in the jar and seal; in a few days the dirt will sink to the bottom and the clean spirit can be poured off to be used again. Clean your brushes after every painting session in white spirit first. Then clean carefully with a rag, and wash the brushes in warm water and soap, rubbing the soapy brush in the palm of your hand to remove any paint. Dry them carefully and store upright. If you accidentally

*Some painting grounds
complete with the
author's paintings*

leave paint on the brush and it hardens, soak in household brush cleaner, then wash as before.

Rags An old cotton cloth or towel is essential for cleaning your brushes and for wiping them when you want to pick up new colours with the same brush.

Mediums You will need to mix your paints with a medium to blend and sometimes thin the colour. The simplest is white spirit. You can use pure turpentine, which smells better but is more expensive, or if you don't like smells try the low odour thinners as an alternative. All these can be used to clean palettes and brushes.

Linseed oil is used by painters who prefer a slow-drying painting with a glossy finish. Also available as a medium is painting medium (a mix of linseed oil, white spirit and oil of spike lavender), which is sometimes sold as

a gel. Pure oil of spike lavender is also available (and smells nicer).

Water soluble oils For the painter who does not like the smell of oil paints these are a good alternative.

Painting grounds A ground is the surface used for painting on. You can paint on many different surfaces, provided they have been primed first (sealed to stop the oil in the paint seeping into the surface beneath). These are some suitable grounds.

Canvas Sold ready primed so you can start painting immediately, canvas is usually cotton or linen material stretched over a wooden frame (known as a support). At the back are small wooden wedges (keys), used to tighten the canvas if it slackens, as canvas is susceptible to changes in heat or moisture in the air. Canvas has a tooth; a slightly textured

surface that helps the paint to grip.

Canvas boards Canvas glued to stiff card and sold ready to use (e.g. Daler Board). This is cheaper to buy than stretched canvas.

Oil sketching paper Usually sold in tear-off blocks, this is primed textured paper ready to use. After painting is completed the paper can be stuck onto a firm surface (usually by a framer) prior to framing.

Hardboard Hardboard or composition board can be used to paint on, but it has to be primed first. Use the smooth side rather than the rough. Acrylic primer is available from art suppliers but you can also use household emulsion paint. For a cheap painting surface, prime the smooth side with three coats of household emulsion (any colour) or wallpaper paste. Painting a diagonal cross from each corner on the back prevents the board from warping. Allow to dry before starting to paint.

A further improvement to this rather smooth surface can be made by covering the smooth side with old cotton sheeting or muslin. Cut the fabric wider than the board. Wring out in cold water and lay in place on the board. Paint the primer (emulsion) over the fabric from the middle out to the edges. This will stick the material to the board. Mitre the edges by cutting the corners off the material and folding them over the board, then paint on to the back of the board. Paint the cross on the back. Allow to dry flat. Apply at least four more coats.

Paper/cardboard If you prime the paper, for example with emulsion (or the leftover paint on your palette), you can paint on it.

Easel When painting in oils it is important that the picture surface is nearly upright. Easels range from the large wooden 'studio' easels through light metal or wood sketching easels for outdoor work, to table easels which,

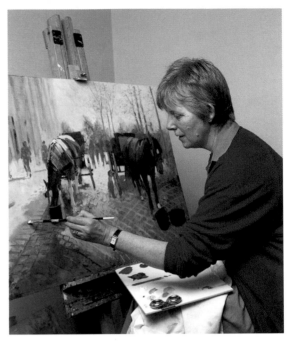

The author at her easel

as their name suggests, can be erected on a table. It is possible to work with the painting leaning upright against the wall on a table, provided you can prevent it from slipping.

Varnish When your painting is dry – which takes several months (white being the last colour to dry) – you need to varnish your painting. This is to protect the surface from damage caused by the air, which will eventually darken the painting. You will need a bottle of clear picture varnish. The picture needs two coats of varnish, the first, known as retouching varnish, being a thinned down version of the second. To make retouching varnish, mix 50% pure turpentine with 50% picture varnish. Apply using a large household or soft-haired brush, laying the painting flat and working from the top to the bottom of the picture. Leave flat to dry (usually in about an hour), then apply the second coat of undiluted picture varnish in the same way.

MAKING MARKS

Start by having a go at making marks with your paints. To get the paint to adhere to the surface, use it with very little medium. The consistency should be like double cream – this will be the way you need to use it throughout most of this book. Try varying the strokes you make. By doing this you will produce a lively surface, which is one of the characteristics of oils.

Brush and knife marks

Marks made by 'buffing' (pushing the brush vigorously onto the surface). This is a good way to apply paint. The paint needs to be thick and creamy. These marks were made with a size 8 round-ended hog bristle brush.

A square-ended brush will give a straight-edged mark. This is useful when painting buildings. These marks were made with a size 6 hog bristle bright.

Lines are best made using a soft pointed brush. Keep your paint soft and creamy by adding slightly more medium to the mix. These were made with a size 4 man-made brush.

Using a palette knife gives robust marks.

A painting knife also gives a raised surface: this is known as impasto painting.

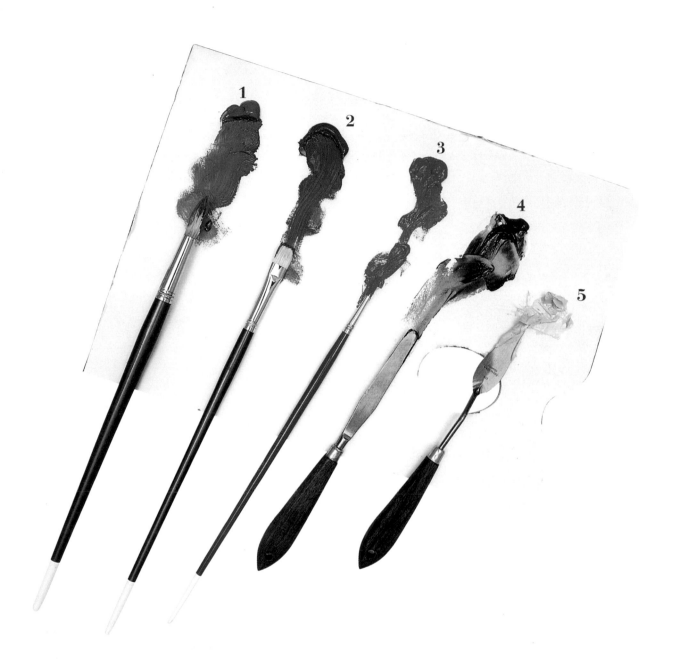

1. *A round-ended hog bristle brush, size 8: this is good for clouds, as it makes rounded marks.*
2. *A square-ended hog bristle bright, size 6: this makes straight-edged marks, useful for painting buildings.*
3. *A soft, man-made brush, size 4: this is useful for fine lines such as twigs etc.*

4. *A palette knife: originally used to mix paint on the palette, it can also be used to paint with. It makes broad, rugged marks.*
5. *A painting knife: a flexible trowel-shaped knife that is good for creating textural effects.*

STARTING WITH COLOUR

Oil colour is distinctive for its richness and buttery consistency. Like any medium, you need to know its physical capabilities. How do you start painting, do you stroke or dab the paint on with your brush? How much medium should you use with it? Can you remove it if you make a mistake?

Get to know your paint

Squeeze these colours out onto your palette and paint marks with them. Get used to handling the pigment, and experiencing its texture. Notice how the colour 'sticks' much better if you dab it on firmly rather than use the wiping method you use when you are decorating a wall. If you don't like what you've done, you can wipe it off again using a rag dipped in turpentine.

Cadmium Yellow Pale

Rose Madder

Cadmium Yellow Pale is a lovely yellow similar to lemon. It mixes well with other colours, and is useful for all painting subjects.

Rose Madder is a rich, slightly pinky red. It mixes to make rich purples and mauves, and is ideal for painting flowers.

Cadmium Red

Cadmium Red is a good all-purpose red.
It is slightly orange in character.

Crimson Alizarin

Crimson Alizarin, a dark, rich red, is a useful
colour for all painting. It is slightly purple, but
not as pink as Rose Madder.

Viridian

Viridian is a very bright
green, which does not look
very natural! However, it is
an excellent mixer when
combined with other colours.
It is very useful for
landscape painting, though
not on its own.

French Ultramarine

Burnt Umber

French Ultramarine is a cool, rich dark blue which mixes well to make other colours. It also makes a good rich black when mixed with Burnt Umber.

Burnt Umber is a dark, rich brown, which is very useful for mixes of landscape colours.

Cerulean

Cerulean is a useful warm blue for sky colour mixes. It also makes a good range of summer greens when mixed with yellow.

Using any colour you choose, try making leaf, grass and twig marks. Use a small, soft brush, and add a little medium to your paint.

Using white

One of the most important features of oil painting is the use of white. White is used to make colours lighter, and to add 'body' (opacity) to colours. Your task as a painter is to produce the effect of three dimensions on two. To be able to do this you need to show light and shadow, which makes things look solid and three dimensional. To understand how to make colours lighter, try painting this cube.

These are the four tones I used in the box. The middle two are made by adding white to Cadmium Red.

1 *Draw a box shape in pencil (you can use a ruler if you prefer).*

2 *Using a small, soft brush, squeeze some red and white paint onto your palette. Paint the side of the box red. Add a little white to the red on your palette to make the colour a little lighter. Apply this to the front of the box. Finally add more white to your mix to make a light pink for the top of the box.*

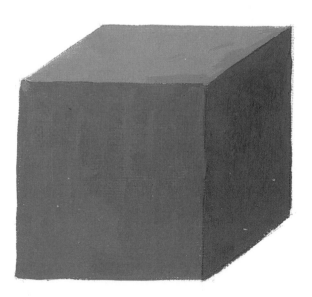

One colour sky

Successful skies will 'make' a painting. Curiously, the quicker you paint them, the better they are. This is because skies are always moving and changing. This sky is painted with just one colour – and white. You will need a small brush to mark out the clouds, then a large brush to paint them. Don't be frightened to have a go with the large brush, you can wipe the paint out if things go wrong.

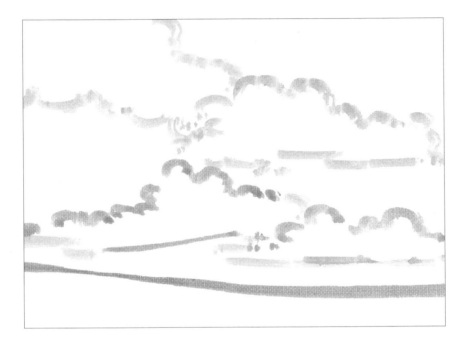

1 *Use a small, soft brush to mix a little Cobalt Blue and a lot of medium to create a watery colour, and use this to mark out your clouds. Clouds become flatter and longer as they recede into the distance.*

2 *Change to a large, round-ended brush and on your palette mix blue with a little white and very little medium. Apply this mix from the top of the picture moving downwards. As you do so, add more white to the mix to make the sky lighter in the distance.*

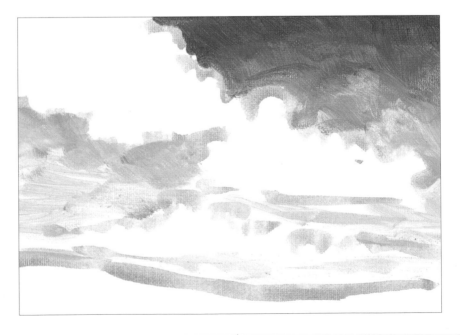

3 *Still using your large brush, mix a medium toned blue (rather like the colour halfway down the sky). Apply this on the undersides of the clouds. This will be the cloud shadow.*

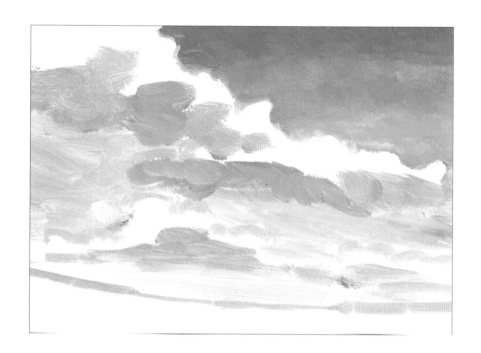

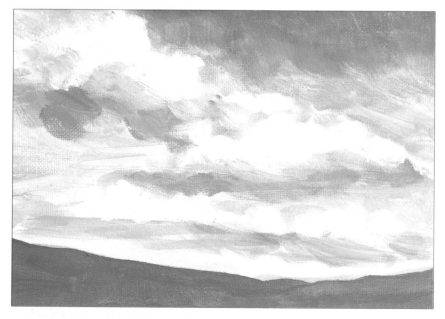

4 *Wipe your brush thoroughly on a rag and pick up a large amount of white. Lay the white paint on thickly with your brush to create the highlights on the clouds. Mix blue with a touch of white for the land.*

What is tone?

Tone is strength of colour. It is the light or dark of any colour. For example, you can have a light tone red or a dark tone red. Tone is controlled by adding more or less white. Colours can also be made darker in tone by adding a dark colour – for example, adding brown to yellow will darken it. Try painting this flowerpot. Tones of brown have been used to make it look round and hollow.

1 *Using a small, soft brush and a thin solution of Burnt Umber, draw the outline of the pot.*

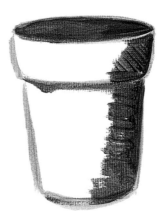

2 *Using Burnt Umber only and a small amount of medium, paint the dark interior, side and rim of the pot.*

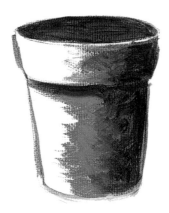

3 *Mix a little white into your brown mix and using small brush marks gently lay the medium tone in the middle, alongside the dark on the side of the pot. 'Feather' the edges (using small brush marks) so that they blend.*

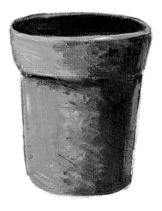

4 *Finally add a large amount of white to your brown mix and paint the light side of the pot. Remember to keep the paint soft but not wet, then you will have no trouble blending it.*

One colour landscape

There is a long history of monochrome painting, which reached its zenith in the nineteenth century when sepia sketches were very popular. As well as being useful ways of learning about tone, they make very effective paintings in their own right. This exercise, which uses one colour and white, shows how colours become lighter in tone as they move to the distance.

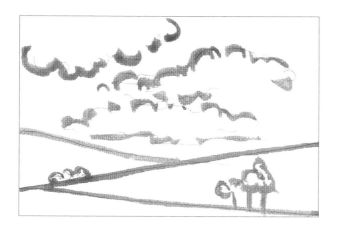

1 Using a small, soft brush, mark out the painting with a thin solution of red. I have used Crimson Alizarin.

2 Using a large, round-ended hog bristle brush, lay in the sky by painting the background sky first followed by the shadow on the clouds. Then add the highlighted clouds in thick white. With a hog bristle bright, mix two tones for the land, using the paler one behind.

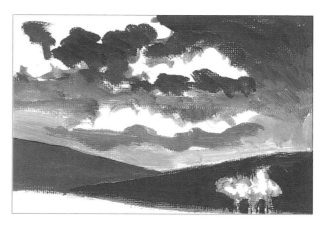

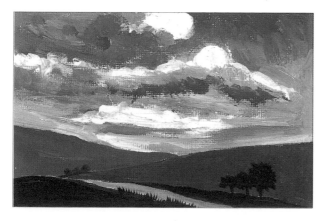

3 Make the nearer hills stronger in tone – you will still need to keep a little white in the nearest land, this gives the paint its 'body'. Finally add the trees, which are the darkest part and therefore have mainly red in them. Paint the road a pale pink.

LIGHT AND SHADOW

As you did with the box, you need to create light and shadows to make things look three dimensional. This applies to everything you see. Always paint when there is enough light to cast a shadow; it will make your job easier. If you half close your eyes when you are looking for shadows you will see them more easily.

Ball

Try this ball in yellow, blue and white.
See how it looks like a flat circle until you add the shading, when it immediately assumes a three-dimensional shape.

Cadmium Yellow Pale Titanium White French Ultramarine

1 *Draw a circle and paint it yellow using a medium-sized hog bristle bright. Use a small, soft brush to neaten the edges.*

2 *Add blue on the right side with the larger brush, and neaten with the small brush. Adding blue to the wet yellow will make green.*

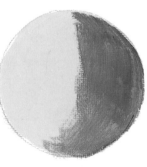

3 *Mix a little white into the blue for the medium tone in the middle of the ball. This will also turn green as it mixes into the yellow.*

4 *Blend the colour into the light area to give a yellow-green ball receiving light from the left, and in shadow on the right.*

Tube

A tube is another simple shape. Again, see how the shading immediately gives the shape three dimensions, and how the cast shadow anchors it to the ground.

Burnt Umber Titanium White French Ultramarine

1 Mark out the shape with a thin solution of brown.

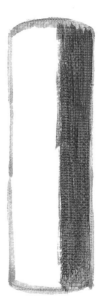

2 Using a small, soft brush, paint the right side using brown and a touch of blue (this will produce a brown-grey colour).

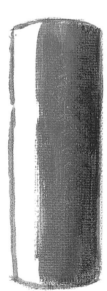

3 Blend a little white into the mix and apply towards the centre of the tube.

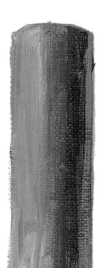

4 Add more white to the left side, blending gently with your brush. Add a thin flat oval (ellipse) as a shadow.

Simple tree

Using the previous exercises try this simple tree. Although not all trees are shaped like a ball, they are often rounded and receive light and cast shadow in a similar way. If you understand this, you will know what to look for when painting trees of different shapes.

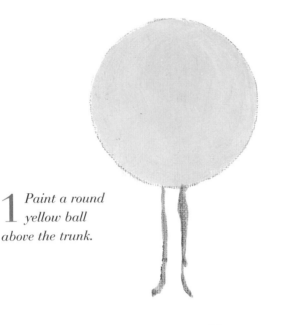

1 *Paint a round yellow ball above the trunk.*

2 *Add blue to the right side of the ball. Add a blue/brown mix for the shadow side of the trunk.*

3 *Mix white into your blue and apply to the wet yellow to make a mid-tone green for the foliage.*

Cadmium
Yellow Pale

French
Ultramarine

Titanium
White

Burnt
Umber

4 *Use the tip of a small, soft brush to make leaf marks in the wet paint. Add the light on the trunk by adding white to your blue-brown mixture. Use some of this mix to create the tree's shadow on the ground.*

Simple building

Try painting this simple building. You can do this with any dark colour plus white. It follows the same principle as painting the cube on p. 17. If you remember that buildings are basically boxes, you will find them far easier to paint. This one has a triangular block on top, forming the roof.

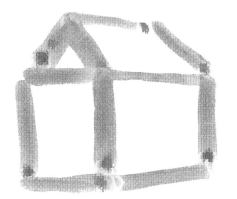

1 Using a small, soft brush and dark paint, mark out a box shape and add a triangular roof. I used Burnt Umber.

2 Mix your colour with white (in varying degrees) to create three tones – dark for the roof, medium for the end wall and chimney shadow, light for the front wall and chimney.

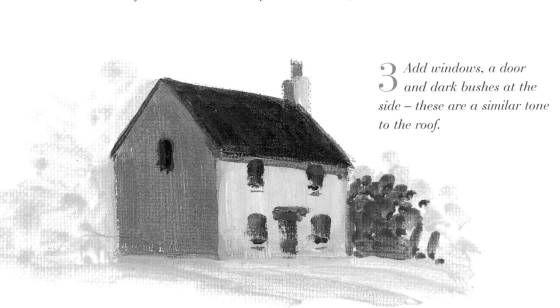

3 Add windows, a door and dark bushes at the side – these are a similar tone to the roof.

BASIC COLOUR MIXING

Colour mixing is a very important part of picture making. There are three primary colours, yellow, blue and red, from which any other colours can be mixed. As a beginner, it is best to keep your colour mixing as simple as you can.

Starter palette

Using as few colours as possible for your starter palette will help you to learn about colour mixing. These are the colours I suggest you have in your basic palette to enable you to practise colour mixing. I have also shown how each makes a lighter colour when Titanium White is added.

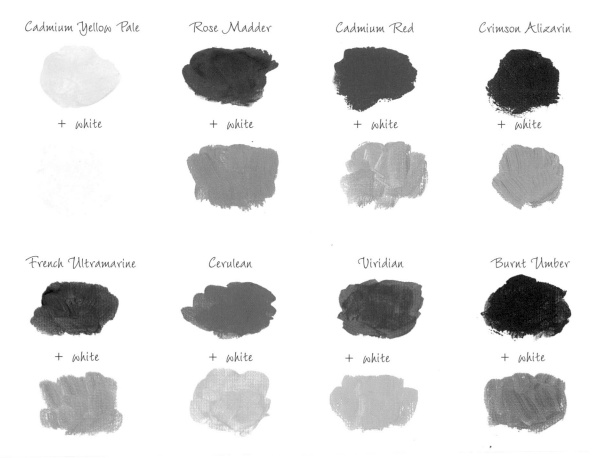

Cadmium Yellow Pale

+ white

Rose Madder

+ white

Cadmium Red

+ white

Crimson Alizarin

+ white

French Ultramarine

+ white

Cerulean

+ white

Viridian

+ white

Burnt Umber

+ white

Primary colours

In theory you can mix any other colours from the three primary colours of yellow, blue and red, and the colours you mix depend on which shades of these colours you use. For example, Rose Madder makes a better purple when mixed with French Ultramarine than Cadmium Red does. Try these colour mixes. The larger patch of colour shows you which colour is dominant in the mix.

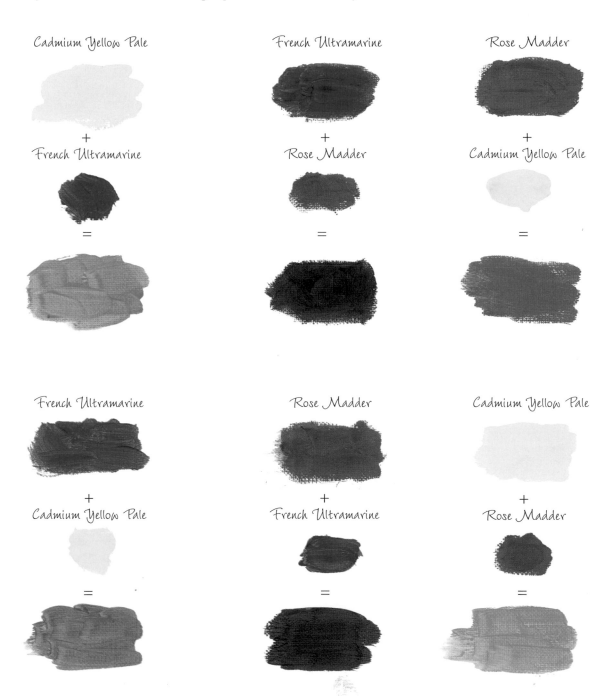

Cadmium Yellow Pale
+
French Ultramarine
=

French Ultramarine
+
Rose Madder
=

Rose Madder
+
Cadmium Yellow Pale
=

French Ultramarine
+
Cadmium Yellow Pale
=

Rose Madder
+
French Ultramarine
=

Cadmium Yellow Pale
+
Rose Madder
=

Mixing greens

Green is one of the most varied of all colours. The rural landscape is full of different greens. Try these greens to experience mixing some. You may find that it helps to make a chart of greens, together with colour 'recipes' to remember how to get that particular hue again, although the best way to learn to mix colours is to make paintings.

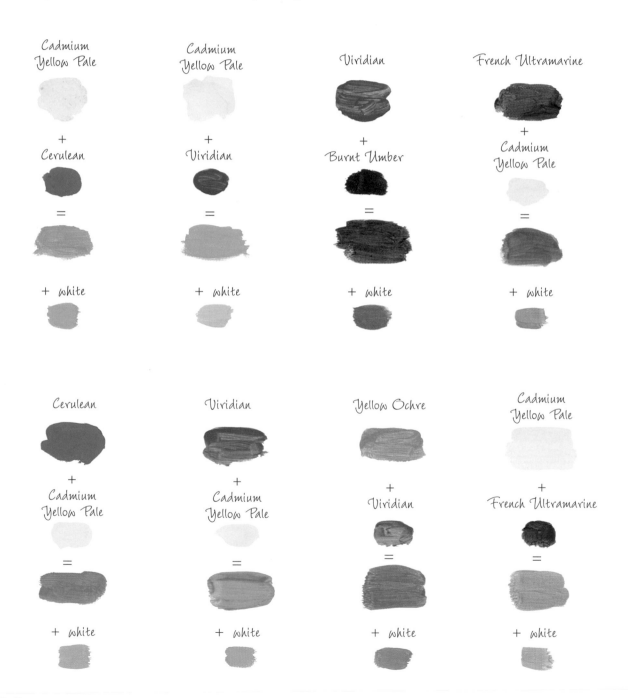

Mixing blacks and greys

It is better to mix your blacks and greys than to use a ready-made colour. Ready-made blacks and greys have a dead feel to them. They are also too neutral, that is they lean towards no particular colour. Greys are always more interesting when they have a colour bias, for example, steel grey is a blue grey so is therefore cool (blue is a cool colour). Try mixing some greys. I have arranged the colours with the predominant colour first. You will see that a variety of greys can be mixed using only three colours but by varying the amounts of colour added to each mix. To make a good black, mix equal quantities of French Ultramarine and Burnt Umber together.

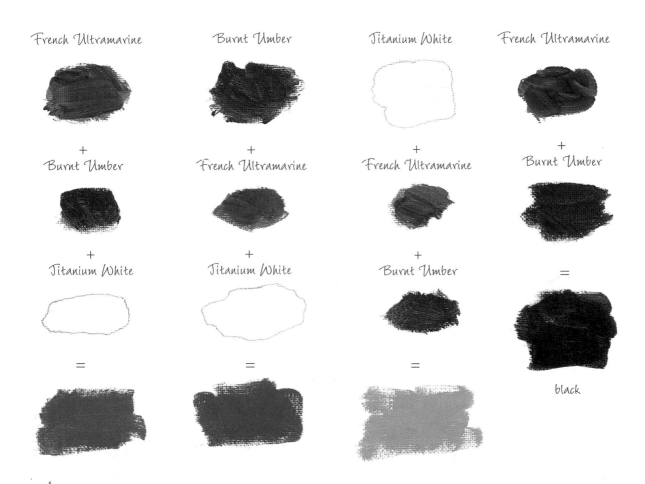

French Ultramarine
+
Burnt Umber
+
Titanium White
=

Burnt Umber
+
French Ultramarine
+
Titanium White
=

Titanium White
+
French Ultramarine
+
Burnt Umber
=

French Ultramarine
+
Burnt Umber
=

black

FRUIT

Fruit is a good still life subject for the new painter as it remains stationary, it does not deteriorate quickly, and it has simple shapes. I have chosen lemons, apples, oranges and grapes which are colourful and fun to paint; once you have tried these why not have a go at some others.

Lemon

This simple picture is created using the three primary colours of yellow, red and blue. Keep your paint generous and thick, and wipe your brush clean on a rag after using each colour.

Lemon Yellow

Titanium White

Cadmium Red

French Ultramarine

1 *Using a medium-sized hog bristle bright, mix yellow with a little white (this makes it opaque). A soft paste is a good consistency. Make a firm curved brush mark one way, then another under it going the opposite way. This will make your lemon shape. Add a small round mark at the end for the point of the lemon.*

2 *Add a little more white into the lemon mix for the highlight colour. This needs to be a stiff mix so that it will lay on the top of your lemon. Try to push the paint on rather than brush it, as brushing can lift the paint off.*

3 *To make the shadow for your lemon wipe your brush on a rag. Mix a little blue and a small amount of both red and yellow. Use no mixing medium. Add a tiny amount of white, just to soften the colour, not to lighten it. Making sure your brush is dry, load paint onto it and brush gently onto the shadow area.*

Apple

This apple is painted in much the same way as the lemon. However, it has a flat top with a depression in the middle where the stalk emerges. Look carefully to see where the highlight occurs: in this case it is around the rim of the flat top.

1 *Take a medium-sized dry hog bristle bright. Moisten with a little painting medium and wipe the brush on your paint rag. Mix your apple colour using yellow with slightly less blue, which gives a yellow-green. Add a little white to soften the colour, not to lighten it.*

 Lemon Yellow

 Titanium White

 French Ultramarine

 Crimson Alizarin

2 *For the highlight, add some white and a little yellow. Load thickly onto the brush. Use one firm stroke on the top of the apple.*

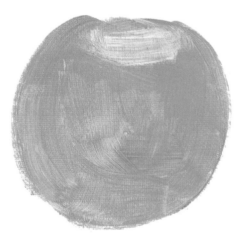

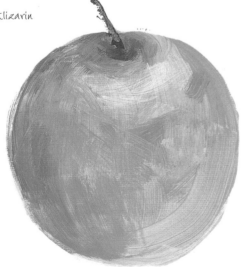

3 *For the shadows, add a small amount of blue and a little red to your basic apple colour mix. Add a tiny amount of white to soften the colour. With a small, soft brush, add the stalk using a mix of blue with a little red and a touch of yellow.*

You can paint 31

Orange

Oranges are one of the most vibrantly coloured fruits. They are ovoid in shape, so ensure that you show this when applying the darks and highlights. Orange skin is the same texture as lemon, so the highlight will appear granular.

1 *Using a medium-sized hog bristle bright, mix yellow with a little red until you have an orange colour. Add a tiny amount of white to make the mix opaque but not lighter. As with the lemon, use a strong curving mark to make the top of the orange. Repeat the curve going the other way to make a sphere. Fill in the middle to create an orange ball.*

2 *For the highlight add a little white and some more yellow; this will prevent the highlight looking too chalky.*

Lemon Yellow

Titanium White

Cadmium Red

Cerulean

3 *Add a little more red and some blue to the orange mixture for the shadow. Also use red and blue for the stem end.*

Grapes

Grapes are beautiful, slightly translucent globes. Watch to see where the highlights lie, and how they lie, around each fruit. The highlight is white with a touch of blue, creating the characteristic 'bloom' on the grapes.

1 *With a small, soft brush, outline the grapes using a thin solution of blue.*

French Ultramarine

Lemon Yellow

Titanium White

2 *Mix blue with a little yellow. Add a tiny amount of white to give it 'body'. This should produce a dark soft green. Paint this all over each grape. This will create the dark part of the fruit. For the middle tone, add more yellow and white to your mix. Apply over each grape covering most of the fruit except the left side which you leave dark.*

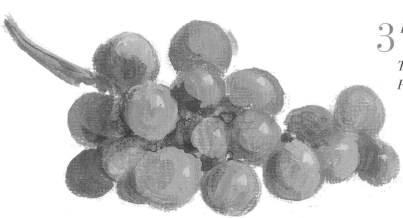

3 *For the light side add white to yellow and a touch of blue. This needs to be a thicker mix. Paint it on the right side of the fruit. Now add the highlight by mixing white with a touch of blue – apply a small dot of thick paint near the light side of each grape.*

Try putting together the elements you have learnt from the last few pages into a still life. After trying this exercise have a go at assembling your own still life. Keep it simple; don't use too many objects and have some touching – it makes a better composition.

1 Draw the shapes out using a thin solution of French Ultramarine. This can easily be removed with a rag dipped in turpentine if you make a mistake. Put a line at the back to mark the surface on which the fruit is sitting.

2 Paint the fruit the same way as you did before. Make sure the light strikes the fruit from the same direction. Don't worry about 'furry' edges on your fruit. These can be corrected when you paint the background.

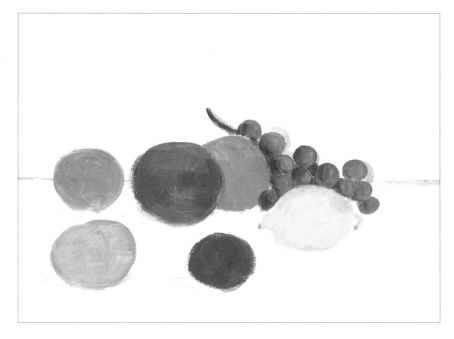

Titanium
White

Lemon
Yellow

Cadmium
Red

French
Ultramarine

Cerulean

Crimson
Alizarin

3 *Add shadows on the fruit as in the previous exercises. For the background, mix white with a small amount of yellow to create a creamy colour. Apply thickly around the fruit. Add cast shadow from the fruit by mixing French Ultramarine, a little red, a touch of yellow and a little white.*

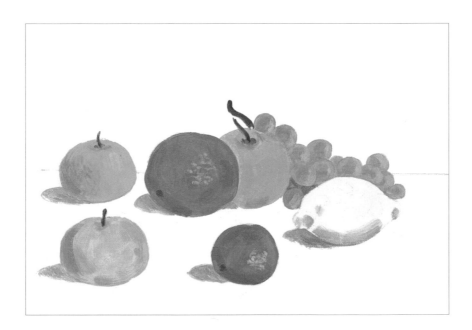

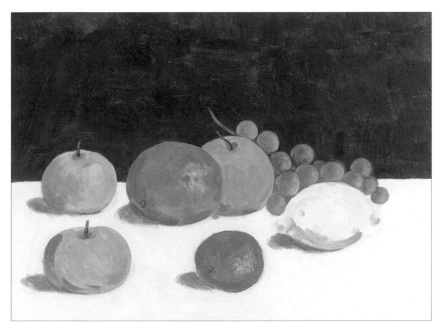

4 *For the dark background add all the colours on your palette together with a small amount of white to make a dark colour. Do not use any medium to mix. Paint all around the fruit, using a small brush (you can neaten the edges of the fruit if required). Paint the rest of the background with a large brush.*

FLOWERS

Flowers are wonderfully colourful and a rich and varied subject to paint, although it can be a little frightening to be faced with your first vase of flowers. The secret is to simplify what you see. One of the ways to help you to draw what you see easily, is to reduce flowers to simple shapes.

Simple shapes

Simplifying flower shapes helps you to understand how the flowers look in different positions. If you get into the habit of looking for simple shapes, your painting will be more successful. Here are some examples of how to simplify flower shapes.

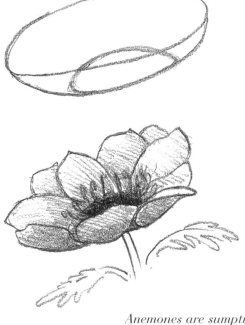

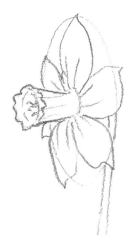

Daffodils may look complicated, but their shape can be simplified to a basic cup and saucer.

Anemones are sumptuous flowers to paint. To avoid painting them too flat, draw them as a bowl shape.

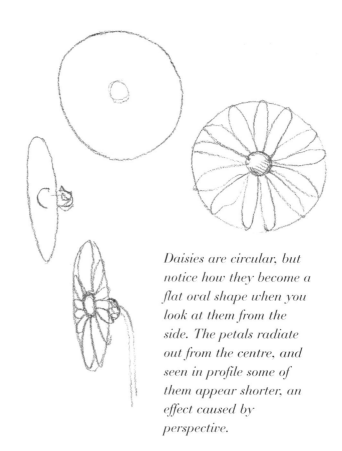

Pansies are circular in general shape, but because of the way their petals overlap each other, the circle becomes divided into a series of fan shapes. See how the lower petal at the front appears larger because it is wholly visible.

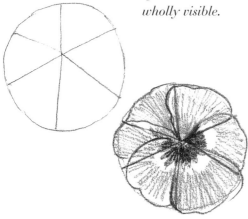

Daisies are circular, but notice how they become a flat oval shape when you look at them from the side. The petals radiate out from the centre, and seen in profile some of them appear shorter, an effect caused by perspective.

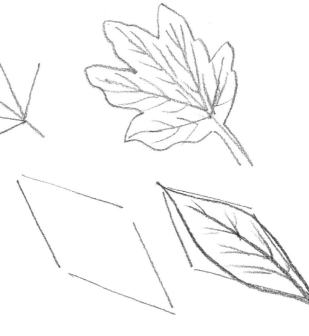

Leaves can also be reduced to simple forms. Use simple shapes such as this diamond, and also watch the way the veins are arranged as these will indicate the leaf shape. Observe how leaves spread out and upwards from the stem in order to catch the light.

Daffodil

Daffodils are some of the most cheerful of spring flowers, and their rich variety of yellows makes them delightful to paint. Remember the cup and saucer shape of a simplified daffodil.

1 *Using a small, soft brush, mark out the flower with a thin solution of brown.*

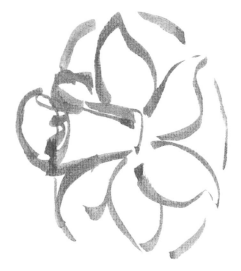

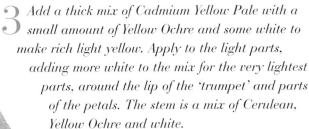

2 *With a hog bristle bright, mark the dark parts of the flower using French Ultramarine with a little red, a touch of Yellow Ochre and a tiny amount of white. Add the medium tone: Yellow Ochre, a little Cadmium Yellow Pale, and some white.*

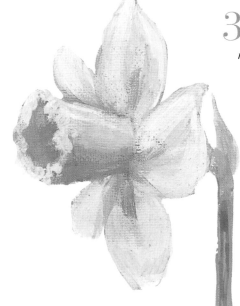

3 *Add a thick mix of Cadmium Yellow Pale with a small amount of Yellow Ochre and some white to make rich light yellow. Apply to the light parts, adding more white to the mix for the very lightest parts, around the lip of the 'trumpet' and parts of the petals. The stem is a mix of Cerulean, Yellow Ochre and white.*

French Ultramarine Cadmium Yellow Pale Titanium White Yellow Ochre

Cadmium Red Cerulean Burnt Umber

Anemone

Try this simple anemone. Anemones are one of the most vivid and richly coloured flowers to paint. Keep the paint thick for the best colour effects.

1 *Using a small, soft brush, mark out the anemone with a solution of blue.*

Rose Madder

French Ultramarine

Titanium White

Burnt Umber

Cadmium Yellow Pale

2 *Mix blue with red and a very small amount of white. Apply with a larger, round-ended hog bristle brush to the dark underside of the flower. Mix blue and brown for the middle of the flower.*

3 *Mix red with a little blue and some white to make a deep rich red for the petals (make sure it is a little lighter than the shadow side of the petal, so that there is a contrast). Add more white and red to the mix for the light edges to the petals. Mix blue and yellow with a touch of white for the leaves, add more yellow and a touch of red for the stem.*

Pansies

Pansies are rich, velvety flowers perfectly suited to the deep rich colours of oils. Doing these step-by-step exercises will build your confidence. Keep your colour thick and creamy to enable you to find the deepest, richest colours.

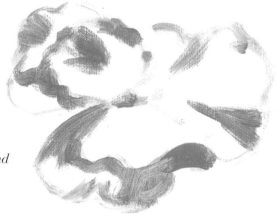

Titanium White French Ultramarine Burnt Umber

Rose Madder Cadmium Yellow Pale

1 With a small, soft brush, outline the pansy, using a thin solution of brown.

2 Mix a soft mauve-grey for the shadows using brown, blue, some white and a touch of red.

3 Using a hog bristle bright, mix white with a little yellow to make cream. Thickly paint the space around the grey shadows, then gently blend the cream into the grey with a small dry brush. Mix yellow with a little red (to make a deeper yellow) and a small amount of white for the yellow centre of the flower. Always keep the paint you use as creamy but as 'dry' as possible, using very little medium.

1 Again, mark out the pansy, this time using a thin solution of blue.

2 Mix blue with red and a tiny amount of white to make a rich purple. Paint the petals with a hog bristle bright, keeping more red in the petals at the front. Add some more white to the mix to create the lighter areas in the petals. Apply the paint gently and quickly so that you do not disturb the paint underneath. Keep the mix thick.

3 For the centre of the flower, add a little red and a small amount of white into yellow (the white will give the colour 'body' and help it to stand out on the dark centre of the flower).

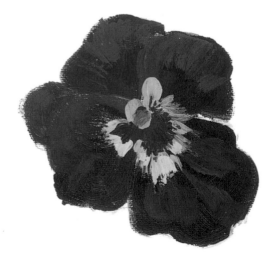

Cadmium Yellow Pale Rose Madder French Ultramarine Titanium White

EXERCISE Paint a vase of pansies

Now that you have tried painting single pansies, have a go at putting some together in a pot. If you remember to start by simplifying the flower shapes this will not be difficult. If you do make a mistake, you can wipe it out with a rag soaked in turpentine.

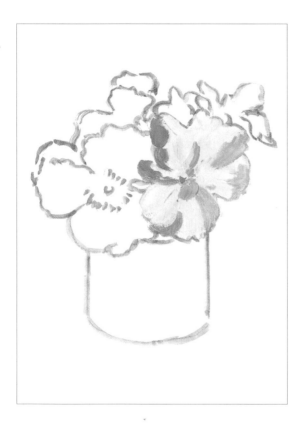

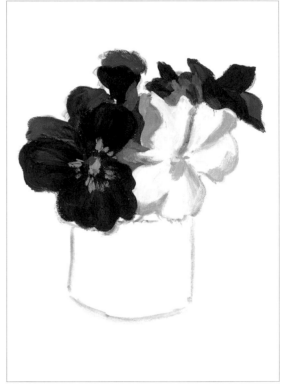

1 Mark out the group of flowers in the pot using a thin solution of blue or brown (both these colours disappear when thicker colour is laid over the top). Paint in the lighter flower first (although in oils you usually paint from dark to light, it will help keep your colours clean on the palette if you paint the lighter pansy first). Follow the steps on p.40.

2 Paint in the darker flowers following the same steps as before (see p. 41). The green for the leaves is made by mixing blue with some yellow and a touch of white. Add the leaves after you have painted the flowers. Don't worry if you get 'furry' edges on your flowers; you can tidy them when you paint the background in at the final stage.

The palette

Rose
Madder

French
Ultramarine

Cadmium
Yellow Pale

Titanium
White

Burnt
Umber

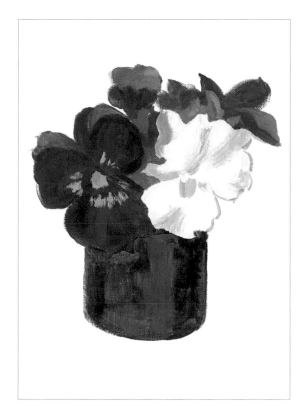

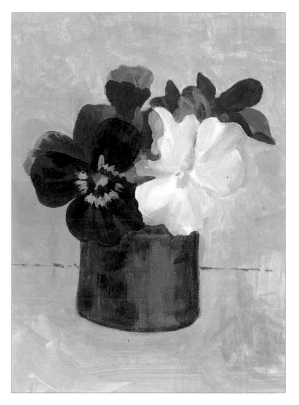

3 Mix brown with a little blue to make a dark brown and paint the darker areas of the pot (keeping the paint thick and creamy). Add a small amount of white to the mix to make a lighter brown, and use this to paint in the highlight on the pot.

4 For the background, mix blue, white, a little red and a touch of brown to make a light, soft mauve-grey. Apply around the group, keeping the paint thick and soft. Use a small, soft brush to apply near the flower edges. Mix blue and brown with a little white to make a dark soft grey. Draw a line across the back to indicate a surface for the vase of flowers.

TREES

Trees are fascinating muddles of leaves and branches. They come in all shapes and sizes and their colours and shapes vary in the different seasons. For the painter, trees add interest in the form of different shapes, tones and colours. They are interesting verticals in a land of horizontals, helping the balance and harmony of a composition.

Sketching trees

Get into the habit of carrying a sketchbook with you. Record the shapes trees make, look at the effect of the leaf shape on the way they grow. Make sketches of various types of tree in different seasons of the year, as I have done here.

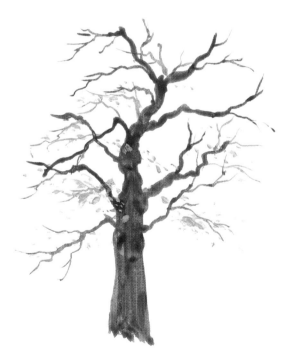

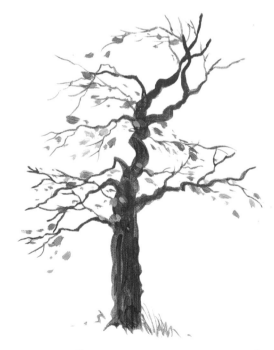

Trees in spring appear to have tiny, 'floating' separate leaves due to very fine twigs supporting the new growth. Paint the leaves just beyond the branch ends.

The same effect is seen in autumn trees as the leaves start to fall. Add enough white to the yellows and reds of the leaves to make them stand out.

Hedges and undergrowth have a rich variety of colours. Here the base has been painted dark first so that the grasses stand out against it.

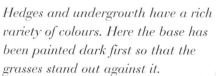

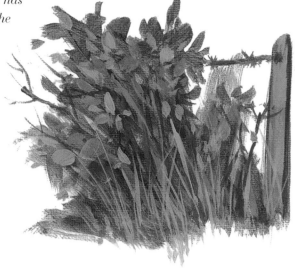

Here the shadows have been added in blue to enhance the white of the snow in sunlight.

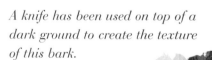

A knife has been used on top of a dark ground to create the texture of this bark.

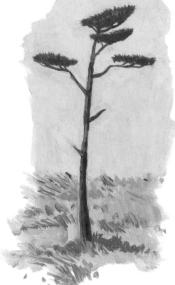

Look carefully at the shapes of trees, and at the angles at which the branches emerge from the trunk. This tree carries its needles high up.

EXERCISE Paint a tree

Trees come in a variety of shapes and sizes, and their shapes and colours can change dramatically throughout the year, making them fascinating to paint. They are often an integral part of a country landscape. Here is a tree in full summer leaf.

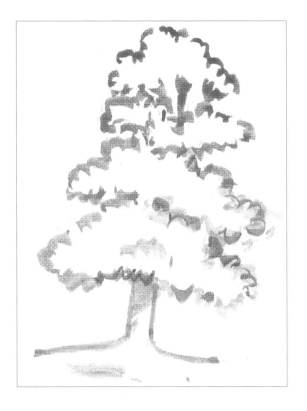

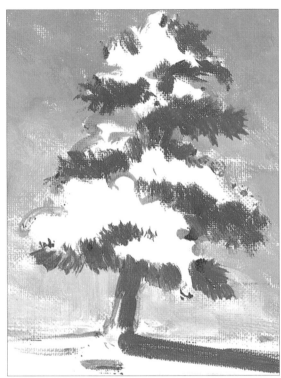

1 *Mark out the tree in a thin solution of blue, using a hog bristle bright. Notice how I have kept the outline simple, to show the main clumps of foliage.*

2 *Paint the sky behind with blue, white and a touch of green. Use blue with green and a little Crimson Alizarin for the dark parts of the tree, including the trunk.*

French
Ultramarine

Titanium
White

Viridian

Cadmium
Yellow Pale

Crimson
Alizarin

Cadmium
Red

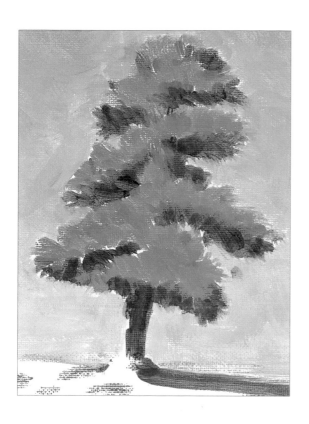

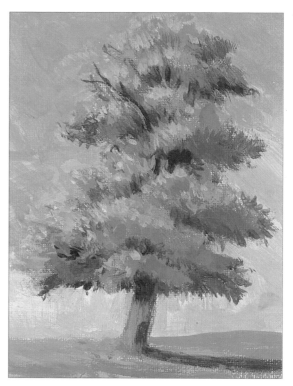

3 *Lay in your medium tones next, using yellow with green, a touch of Crimson Alizarin and some white. Work this over most of the tree, keeping the mix 'dry'.*

4 *Finally, add the light parts with a small, soft brush: yellow with white and a touch of green. The colour should be a light yellow-green, with plenty of white in it, and you should keep the paint thick. Add the trunk by mixing yellow with a little Cadmium Red, a touch of green and some white.*

SKIES

Skies are infinite in their variety. Stormy skies, sunny skies and sunsets can all set the mood and atmosphere of a painting. They are almost always easier to paint if they are done quickly, which also means using large brushes – that way you will feel the wind and fresh air in your work.

Cloudy sky

Clouds are solid objects in that they receive light and cast shadow. For most of the day the light is shining above the clouds, which means they are lit from above or to one side. As the sun sinks the light shines from beneath the cloud, so the highlight is on the underside of the cloud mass.

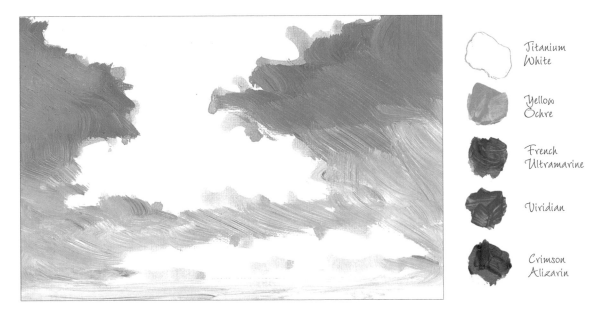

Titanium White

Yellow Ochre

French Ultramarine

Viridian

Crimson Alizarin

1 *With a large, round-ended brush, mark out the sky using a wet mix of blue and medium. Mix blue with a little green and some white for a 'summer' blue. Paint in the sky (don't worry about going over the cloud edges, you can paint that out later). Keep the consistency of the mix stiff. Add more white in the distance and the sky will appear to recede.*

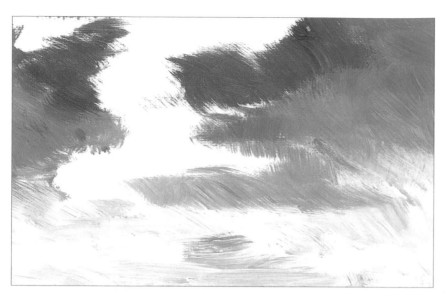

2 *Add red to a larger amount of blue and a little white and paint on the*
shadow and undersides of the clouds.

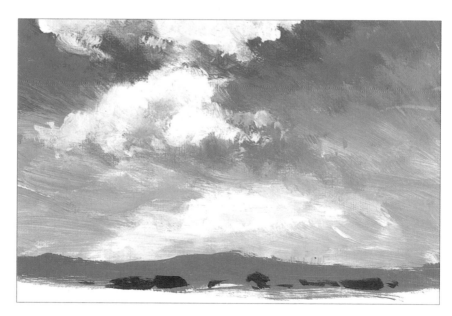

3 *With a hog bristle bright, mix ivory (white with a touch of yellow) and*
apply to the light parts of the cloud. Blend the light into the shadows,
keeping the lightest parts of the cloud unblended. Mix your shadow colour
again (blue, red and white), add a little green and paint the hills.
The trees are blue, green, a little red and a touch of white.

Different skies

If you always make your sky lighter at the back of the painting you will make the picture appear to recede. Even if you have stormy clouds in the distance, they must not be stronger in tone than the darkest tones in the front of the painting.

This sky is Cerulean and white. Cerulean gives a feeling of warmth and summer to a sky.

French Ultramarine mixed with a little red and white gives thundery skies. Yellow and white have been added near the horizon for contrast. French Ultramarine mixed with red and a small amount of white was used for the hills in the distance.

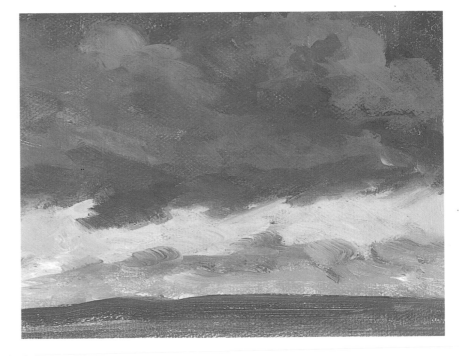

 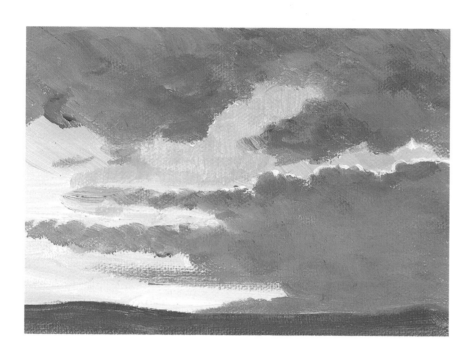

Titanium White Cerulean French Ultramarine Cadmium Red Yellow Ochre Burnt Umber

A combination of Cerulean and white in the background and French Ultramarine with red (keep more blue than red in the mix) and white in the clouds in front, created this sky. Yellow mixed with white made the gold edges to the clouds. The land is French Ultramarine, brown and white.

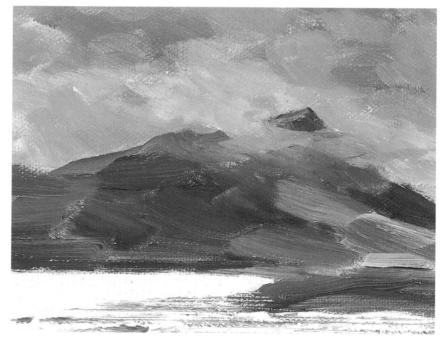

French Ultramarine with Cerulean, a little brown and some white made this mountain sky. The mountain was the same mix with less white added. White was then added to the sky and worked gently into the colour in front of the mountain for mist. It is quite easy to create these effects in oils.

DEMONSTRATION SUNSET

AT A GLANCE...

1

2

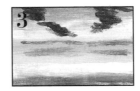
3

4

1 Draw a straight line just over halfway down your picture. Using a hog bristle bright, mix Cadmium Yellow Pale and a little white. Paint a broad band across the line. Add more white top and bottom so the colour becomes paler near the edges.

2 Mix blue with white. Paint a band at the top and bottom of the picture, adding white to pale the edges. Gently brush into the edges of the yellow, adding more white. Using a small, soft brush, streak red with a little white across the yellow band.

The palette

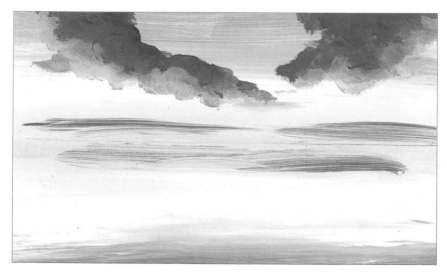

 Cadmium
Yellow Pale

 Titanium
White

 Cadmium
Red

 French
Ultramarine

 Raw
Sienna

Burnt
Umber

3 Mix blue with a some red and a little white to make a soft dark for the clouds. Apply with a hog bristle bright.

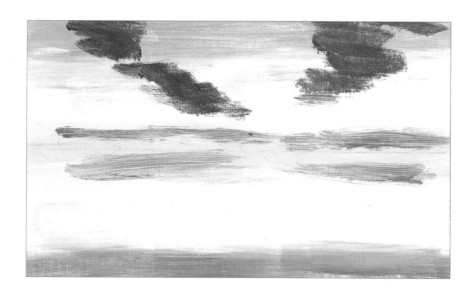

4 With a small, soft brush mix Raw Sienna with white and add the lights at the bottom of the clouds.

You can paint 53

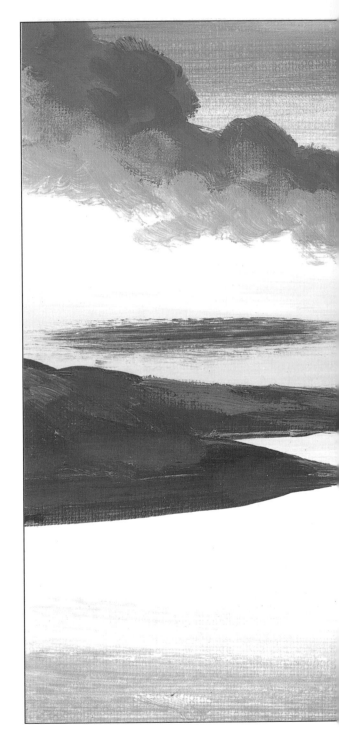

5 *Finished picture:* *Oil sketching paper,*
19½ x 13 cm (7½ x 5 in). I have added the
windmill as a focal point and to add drama to
the sunset colours. Try out the simple shapes
first on a piece of paper. The windmill is a flat-
topped cone, with a smaller half circle on the
top. The sails can be marked out with pencil
when the background is dry, then add paint
using a small, soft brush. The colours used for
the windmill were blue, Yellow Ochre, a little
brown and some white (to make a soft dark).
Remember, if it doesn't go right first time you
can wipe the paint off. Keep the paint thick and
creamy, except for the sails where you can use
more medium so that the paint can be applied
more easily.

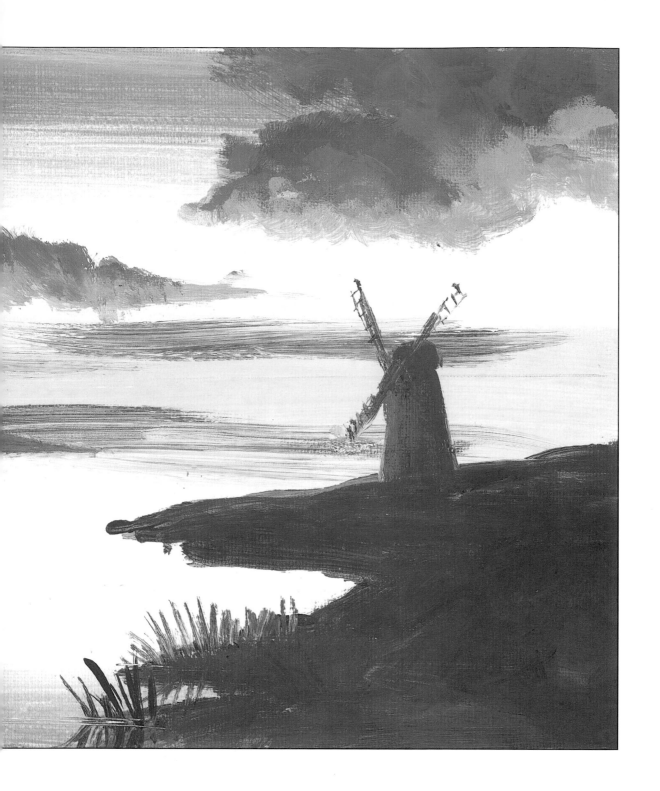

LANDSCAPES

Almost all painters want to do landscapes. The pleasure of being able to record a delightful or interesting view is a common aspiration. It is easy to make the mistake of struggling too much with colours: keep your colour mixing, and your picture, as simple as possible.

Foregrounds

Foregrounds are important supporting players in your painting. If you can think of a picture as something the eye has to be led through and around, until it reaches the focal subject, then the foreground is there to help point the way. It also sets the scale of the picture. Unless the foreground is the subject of the composition, make sure that it does not intrude and distract the eye.

A clump of plants, painted with a fluid solution of paint (French Ultramarine, Yellow Ochre and a touch of white). Using a small, soft brush and softer paint (add a little more medium) creates more graceful 'organic' shapes. The colour has been kept slightly neutral to prevent the shape from becoming dominant. Don't use strong yellow or red colours here.

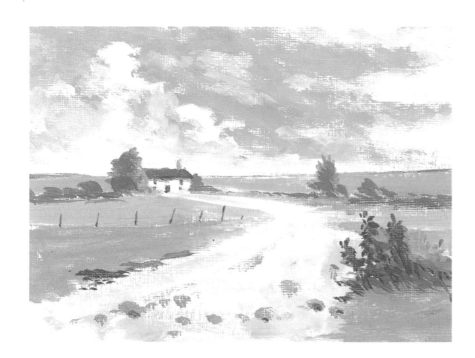

A path or road leading into the picture is a good compositional device. Pathways help lead the eye around the picture. Ensure they lead in and not out of the painting. Keep the path light in tone at the back of the painting, stronger in the foreground. I used Cadmium Red, Cadmium Yellow Pale, Yellow Ochre and white.

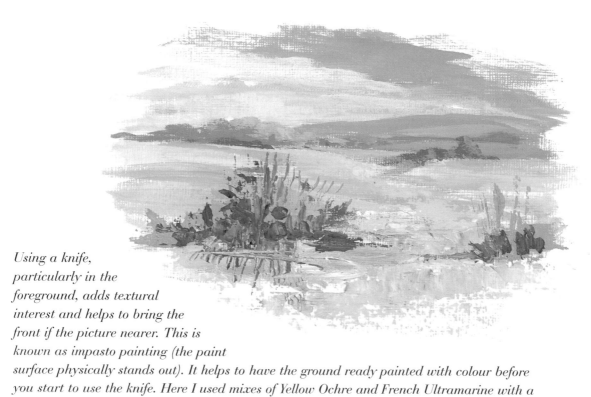

Using a knife, particularly in the foreground, adds textural interest and helps to bring the front if the picture nearer. This is known as impasto painting (the paint surface physically stands out). It helps to have the ground ready painted with colour before you start to use the knife. Here I used mixes of Yellow Ochre and French Ultramarine with a little white. Load a lot of the paint mix onto the knife edge. Keeping your forefinger down on the blade, lay the knife on its side on the surface and drag it in the direction required.

Aerial recession

In the distance, objects and land appear paler and bluer. This effect, known as aerial recession or aerial perspective, is caused by moisture and dust particles in the air. You need to use aerial recession if you want to create the feeling of depth in your painting. Here are four pictures of the same landscape showing the effect of aerial recession on various colours found in the four seasons. In all the pictures, white has been used to achieve the softness of the colours in the distance.

Spring. The sky is Cerulean and white, the distant hills a mix of French Ultramarine with white. Cadmium Yellow Pale with white is smudged across to suggest sunlight. The foreground is Cadmium Yellow Pale, a little Cerulean and some white, the trees Cerulean with a little Yellow Ochre.

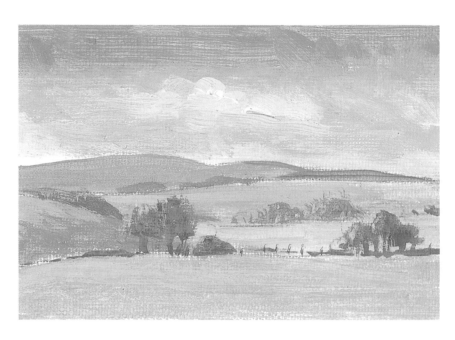

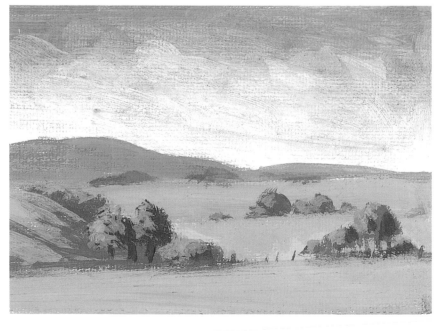

Summer. Mostly the same colours and tones as spring, but with a little Yellow Ochre in with the Cadmium Yellow Pale for the land. A mix of green and Yellow Ochre with a touch of brown is used for the dark parts of the foreground trees. Even in these a tiny amount of white is added.

Cerulean

French
Ultramarine

Cadmium
Yellow Pale

Titanium
White

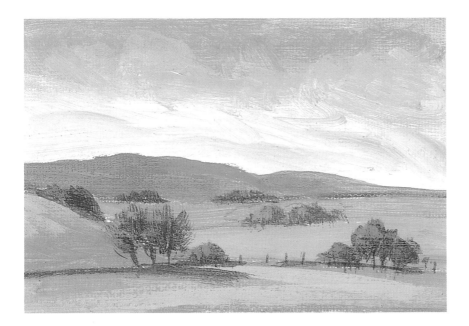

Autumn. Here the same soft colours are used for the back, but slightly more Cerulean in the background hills. The main difference is the use of Yellow Ochre, which is a darker 'old' yellow, added to a little Cerulean and white for the land.

Winter. Here much more grey is apparent in the painting. This is achieved by mixing brown with Cerulean and some white. French Ultramarine and a touch of brown is used for the trees and mixed with white to make the shadows on the snow. This blue gives a cooler feel to the landscape.

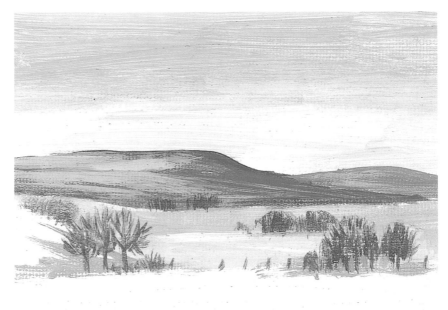

Landscape details

Just as man has added features to the landscape, you should paint the land, then superimpose walls, fences and gates on the background. Paint the land fairly dry (not too much medium added to the paint, and the paint soft and buttery), and then you will be able to paint on top.

For a brick wall, paint the mortar first then add the bricks, making sure that you keep the course of the wall straight. Use your square-ended brush, keeping it well loaded with paint.

Stone will vary in colour according to its type. Check the colour of the local stone before you paint a stone wall onto your landscape.

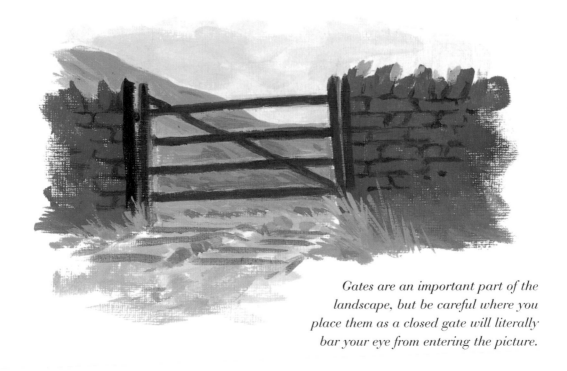

Gates are an important part of the landscape, but be careful where you place them as a closed gate will literally bar your eye from entering the picture.

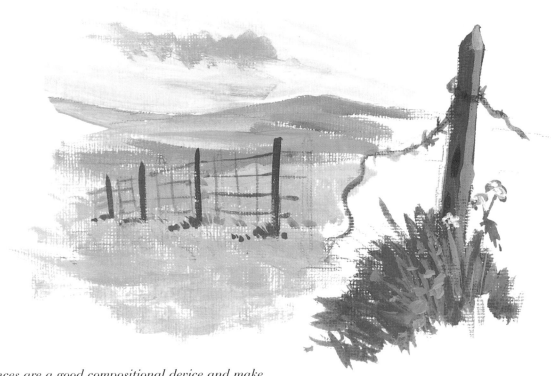

Fences are a good compositional device and make
good shapes in contrast to the solidity of the land. Ensure if you are adding a fence or wall that
it helps the eye to travel round the picture. A wall or fence leading straight out of the picture will
take the eye with it, but a fence leading into the picture will lead the eye in.

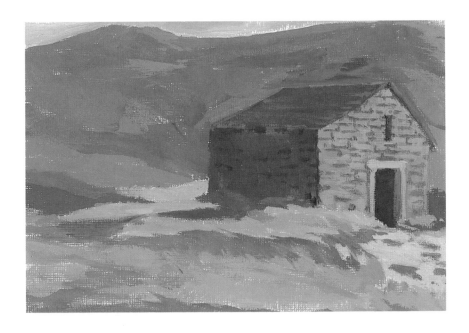

This old barn shows
the amount of detail
needed when you are
painting stone in the
middle distance. Note
how detail is lost in
the shadows, and
how a very old
building 'weathers'
into the same colours
as the landscape.

DEMONSTRATION LANDSCAPE

AT A GLANCE...

1 Mark the painting out using a thin solution of blue. Keep it very simple, only showing the outlines of the main elements in the picture.

2 Paint the sky a mix of blue and white. Add a little yellow to the white of the clouds.

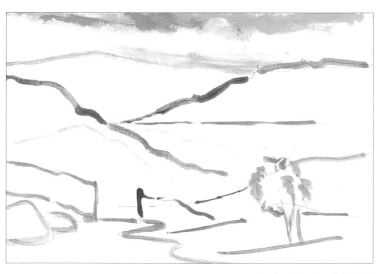

The palette

**Cadmium
Yellow Pale**

Cerulean

**Cadmium
Red**

**Titanium
White**

**Raw
Sienna**

3 *Paint the distant sunlit hills using yellow, white and a small amount of blue. Keep the mixture creamy in consistency and the colour light for these distant hills. The darks on the hills are applied using a mix of blue, red, a little yellow and a small amount of white. The same colour is used for the stone wall and the shadow on the tree.*

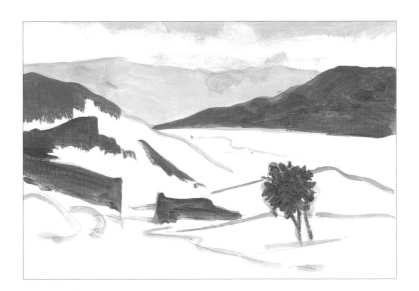

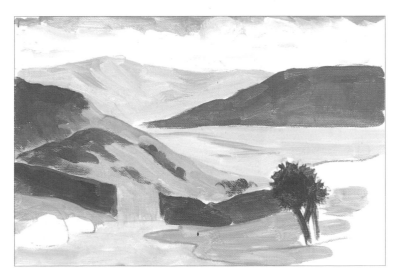

4 *The light areas of land are applied with a mix of yellow, white and a little blue. There is plenty of white in this mix, particularly at the back of the picture. Add more yellow towards the front of the painting. The hill on the left is painted with Raw Sienna and white, which makes a soft sandy colour.*

5 *Finished picture:* *Oil sketching paper,*
18 x 13 cm (7 x 5 in). Paint your trees in
the distance so they have flat bases and round-
ed tops, using blue with yellow, a little red and
some white (to make a soft dark). Mix a strong
dark mix of blue, red and a little yellow for the
rocks. Use a mix of yellow with a smaller
amount of blue and a touch of white for the
foreground grass. Finally use the same colour
for the light parts of the tree. The light colours
on the rocks and tree trunks are the same
colours as the path (Raw Sienna, white and a
touch of blue). Place the gate using the same
dark mix as the walls (blue, red, a little yellow
and a touch of white) and paint in using a
small, soft brush and a more liquid mix of
paint (this will help you to paint smooth lines).

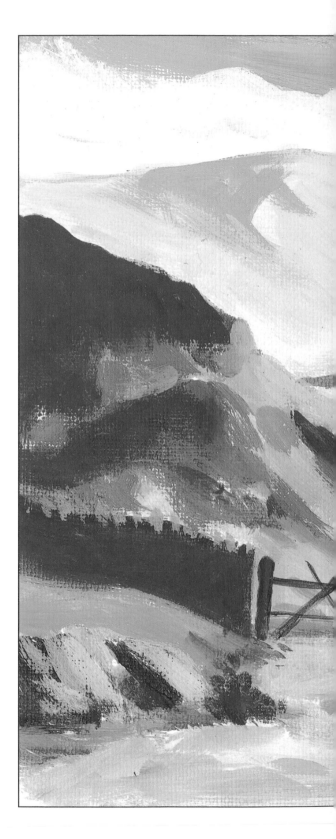

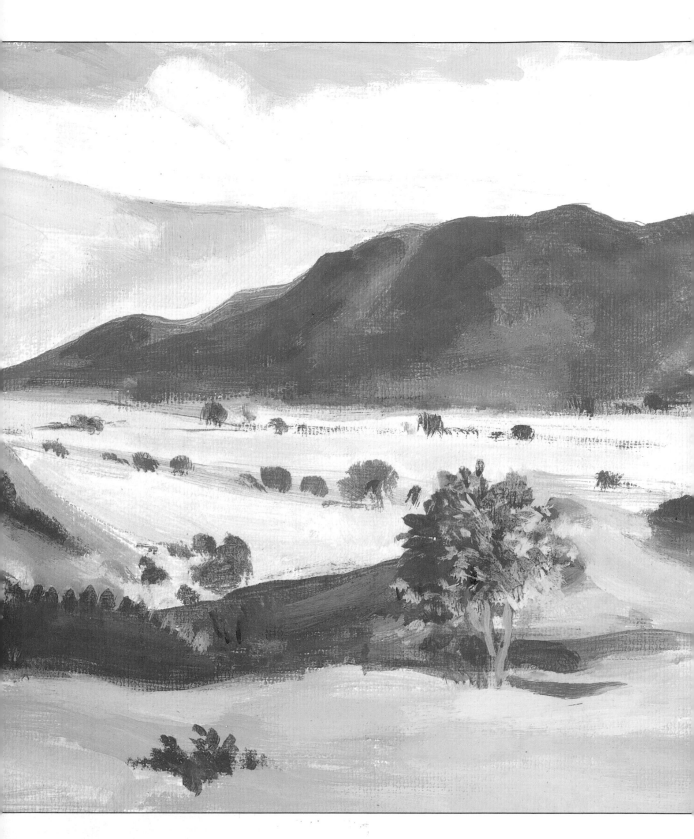

BUILDINGS

All building are basically boxes. If you keep that in mind you will feel more confident about tackling them. Although buildings come in many different shapes and lots of styles, you can still reduce the shapes to a basic box. Remember to look for the way the light falls on the 'box', which will give your building its three-dimensional appearance.

Whitewashed house

Pure white as a colour is never natural. There is usually a bias towards another colour. In this case the sun is out, so the wall appears cream. Don't be afraid of making strong shadows, they will help to create more feeling of sunlight.

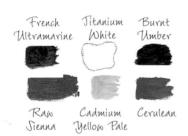

French Ultramarine Titanium White Burnt Umber

Raw Sienna Cadmium Yellow Pale Cerulean

1 *Draw out the basic shape in French Ultramarine with a small, soft brush.*

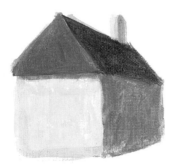

2 *The cream wall is a mix of Raw Sienna and white. The shadow is French Ultramarine and white. The roof is French Ultramarine, Burnt Umber and a little white.*

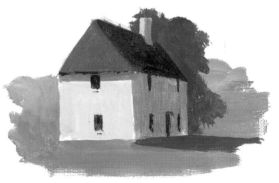

3 *Dark green background and shadow are French Ultramarine, a little yellow and a touch of white. Light greens (Cerulean, yellow and a touch of white) complete the scene.*

Brick farmhouse

This is not a difficult shape to draw if you simplify it to two boxes joined at right angles. Make sure you mark the shadow on the roof, and that cast by the left part of the house.

French
Ultramarine

Cadmium
Yellow Pale

Cerulean

Burnt
Umber

Cadmium
Red

Titanium
White

1 *Draw out the basic shape with a thin solution of Burnt Umber using a small, soft brush.*

2 *Make a soft orange by mixing white, yellow and a little red. Use this for the sunlit walls. Make a darker version for the shadow areas by adding French Ultramarine.*

3 *The thatched roof is a mix of brown, French Ultramarine, white and a little yellow to make the sunny areas. The green foreground is yellow, Cerulean and a little white; the dark green is French Ultramarine and yellow.*

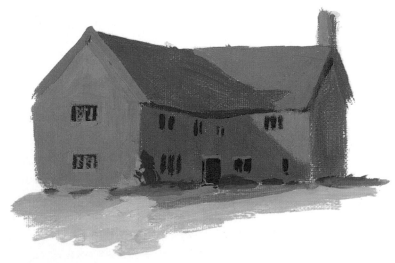

Timbered house

Although this house looks complicated it is still basically a box shape. Make sure you paint a strong shadow on the building – this will increase the effect of sunlight. The timbering is applied in the final stage.

1 *Draw the building with a small, soft brush and a thin solution of blue. With a hog bristle bright paint the shadowed wall and chimney blue-grey (blue mixed with a little red and some white). Roof shadows, door and windows are blue and brown.*

French Ultramarine

Titanium White

Yellow Ochre

Burnt Umber

Cadmium Red

Cadmium Yellow Pale

2 *The light thatch on the roof is a mix of brown with red and white. Use Yellow Ochre with white for sunlit walls and chimney.*

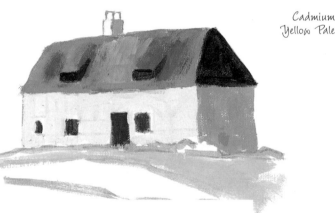

3 *Using the small brush add timbering (brown with a little blue and white). Use the blue-grey of the wall for the shadow of the eaves, some of the thatch and door and window detail. The chimney and flowers are white, red and a little Yellow Ochre. The path is Yellow Ochre, white and a little red. The grass is Cadmium Yellow with blue and a little white.*

Village scene

Construct a group of buildings as a series of different sized boxes joined to each other. If you keep your compositions simple you will soon gain more knowledge about the effects of perspective in your paintings.

1 *Draw in the buildings in blue with a small, soft brush. Using a hog bristle bright, mix blue and white for the cottage walls and chimneys, and brown, blue and a touch of white for shadows on the roof and church. Foliage is blue, yellow and a touch of white.*

 Titanium White Cadmium Red

Cadmium Yellow Pale French Ultramarine Burnt Umber

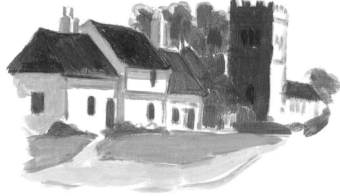

2 *The middle roof is blue with a little red and white, the others brown with yellow and a little white. The path is yellow with red and white, the grass yellow with a little blue and some white.*

3 *Mix white with a little yellow for the sunlit walls, roofs and chimneys. Place details on doors, windows and the church gate with a small brush in brown, blue and a touch of white. Window detail is blue with a little brown and some white. Chimneys are red mixed with yellow and white.*

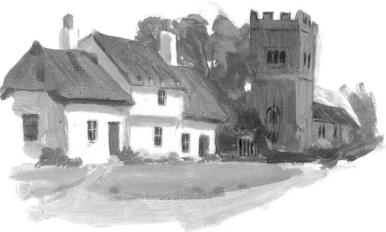

FIGURES

Adding human beings to your pictures will literally add life. They need not be difficult to paint if you know what to look for. Unless they are going to be the subject of the picture, it is better to place them in the middle distance. Use your figures strategically to point the eye to the focal point in the picture.

Simplifying figures

Observe how figures walking towards or away from you make a long cone or carrot shape. They also 'lose' their necks, as the head is slightly in front of the body. Figures walking away into the picture draw the eye in with them, so are good as a compositional device.

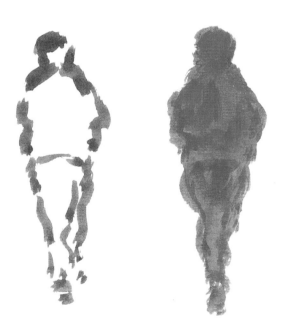

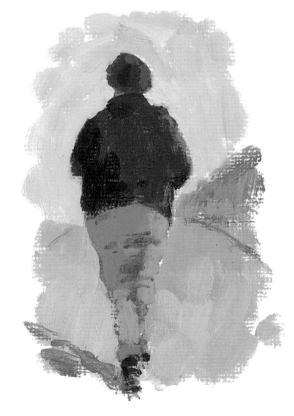

When people move, bits of them go missing. A figure who walks has one foot off the ground, so if you paint your figure with one leg shorter it will suggest movement.

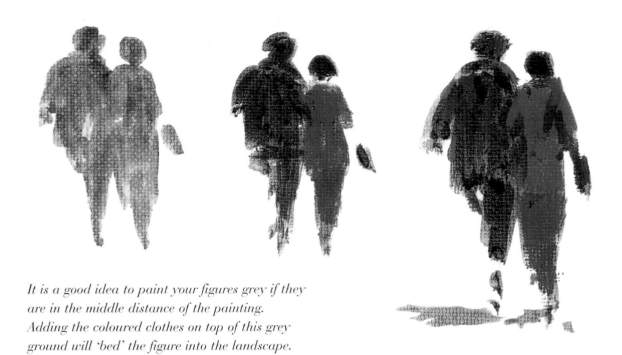

It is a good idea to paint your figures grey if they
are in the middle distance of the painting.
Adding the coloured clothes on top of this grey
ground will 'bed' the figure into the landscape.

Titanium White · Cadmium Yellow Pale · Cadmium Red · Burnt Umber · French Ultramarine

For both these groups of figures I used a grey
mix of blue and brown as a basis and to
create the shapes required. Then dark colours
were added for the shadows, and finally light
tones were added plus any details.

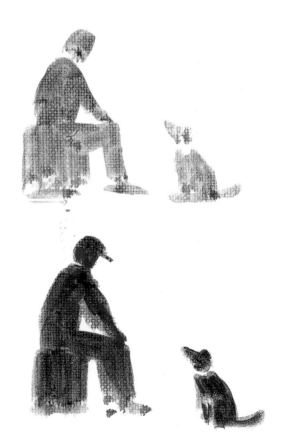

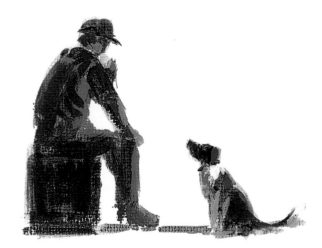

Sketching figures

Observe people doing various things – the way their shoulders curve, the angle of their bodies when they are standing talking (people rarely stand upright). Look carefully first before you try to make a sketch.

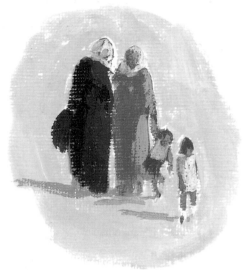

See groups of figures as a series of shapes joined to each other, rather than as individuals. At this distance, details are not discernible.

Adding tools to a simple figure will identify them: here I have added a crook for a shepherd.

Watch how the shoulders curve into a bow shape when figures are carrying a heavy object.

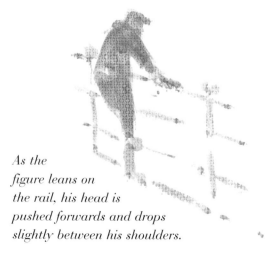

As the figure leans on the rail, his head is pushed forwards and drops slightly between his shoulders.

The woman and children make a loose triangular shape as they stand in a group.

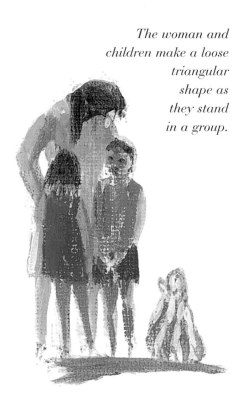

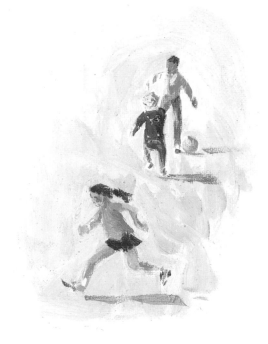

Children are demonstrative and energetic as they move. Watch how their arms swing and wave as they play. On a young child the head is bigger in relation to the body.

People rarely stand with their weight equally on each foot. Standing figures shift and transfer their weight from foot to foot, which tilts the body slightly.

Here I have adapted the basic walking figure on p.70 into a man and his dog. Adding shadows on the ground for each figure anchors them down to a surface.

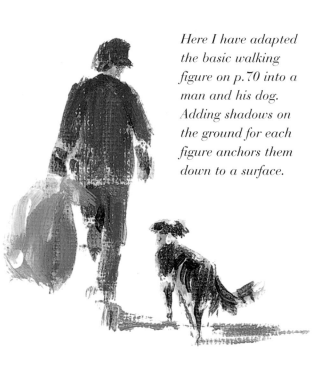

ANIMALS

Painting animals is not difficult if you break down the shapes into something manageable, such as a geometric shape. Of course, no animals will stand patiently while you paint them into the scene, so it is helpful to work from sketches or even photographs.

Hen

Birds come from eggs – and when painting them, that is a very good place to start. An egg is a good shape on which to base a bird. All you need to do is work out which angle the egg is positioned at. In chickens the shape is slightly tilted. Add some triangles for the head and tail feathers, another small triangle for the head, and you will be able to capture the shape and pose.

1 *Mark out the hen using the egg shape, with a thin solution of blue and a hog bristle bright.*

2 *Paint in the darks on the bird: blue with red and a little white. This colour is also used for the bird's shadow (below).*

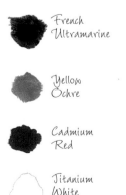

French Ultramarine

Yellow Ochre

Cadmium Red

Titanium White

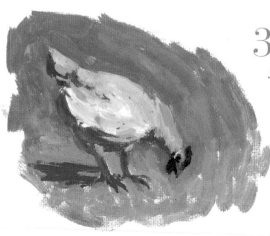

3 *Using a small, soft brush, mix white with a little yellow for the light parts of the body. Legs are yellow with a little grey from the body shadow. Add red with a little white for the wattles, and mix yellow with a little white for the background.*

Ducks

Ducks are found in the wild, in farmyards and in most public parks, anywhere where there is water. One of the important things to notice is that when the birds are swimming, they displace the water in a curved shape around their bodies, not a straight line.

1 *Construct the duck in the same way as the hen, using the egg shape. The shape tilts slightly to point downwards, and ducks have more sinuous necks than chickens.*

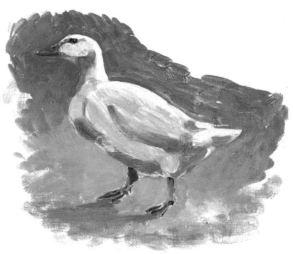

2 *Paint the bird with cream made from white and yellow. The feather shadows are Cerulean, red and white. Beak and feet are a mix of red and yellow with white. The ground is yellow with Cerulean and white, and the shadows cast by the bird are Cerulean, red and white with a small amount of yellow.*

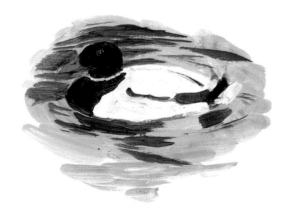

Paint the drake in the water with yellow and white for the light parts, and brown, red and French Ultramarine for the dark head and neck. The beak is yellow with a touch of red and white. The water is Cerulean and white over the whole area first, then yellow mixed with French Ultramarine and a little white for the ripples.

Yellow Ochre Titanium White Cerulean Cadmium Red Burnt Umber French Ultramarine

Sheep

Sheep are features of many landscapes that are farmed, and add an air of peaceful tranquillity to a scene. However, they are almost never in the right spot to paint, or else they move on just as you are about to start painting. It's a good idea to sketch them whenever you get the chance.

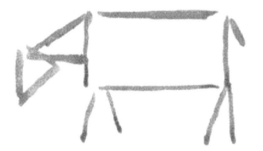

1 Using a hog bristle bright, draw out the simplified shape with a thin solution of blue.

2 Fill out the profile of the sheep over the framework. Add shadows of blue mixed with red and a little white.

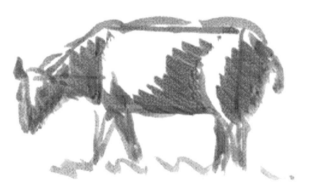

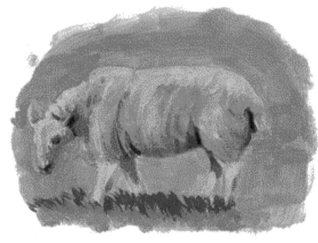

3 Mix Raw Sienna with white and a touch of blue to make the light parts of the sheep. Add details (eyes, nose, creases in the wool etc.) with blue and red and a small, soft brush. Paint the grass with yellow, blue and some white. The shadow is the same mix with more blue.

Titanium White Raw Sienna French Ultramarine Cadmium Yellow Pale Cadmium Red

Cow

Cows, like sheep, add interest and atmosphere to a landscape. They are more striking than sheep, especially the Friesian breeds with their black and white markings. Use these markings to help you to construct their form.

1 *Draw out the shape, using a box as the basic frame.*

French Ultramarine

Titanium White

Burnt Umber

Cadmium Red

Cadmium Yellow Pale

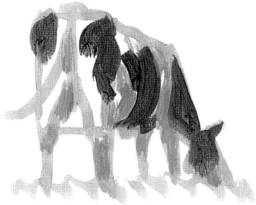

2 *Use blue with white for the shadows on the cow. Mix blue and brown to make black. Use this to paint the patches on the cow's coat. These will describe the form and keep the cow rounded.*

3 *Mix white with a touch of yellow for the highlights on the coat. Add red with white for the teats. Mix yellow with white and a little blue for the grass. Add more blue for the shadow cast by the cow.*

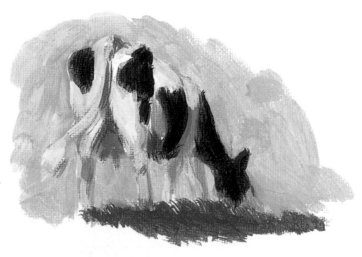

EXERCISE Paint a rural landscape

Try painting this rural landscape. It has three major elements: sky, land and animals. You have had a chance to practise these earlier in the book, this is your opportunity to combine them. This painting may appear complex, but just break it down into stages and tackle each stage in turn.

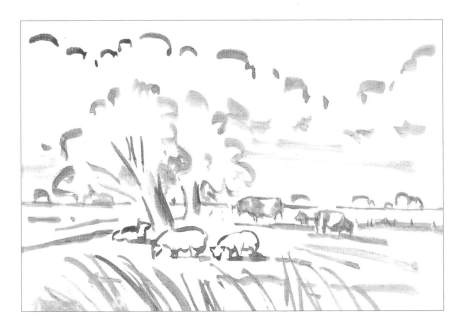

1 Mark out the picture using a thin solution of French Ultramarine. Don't worry if the lines appear thick or fuzzy, you will be covering them with paint later and can 'tidy' the shapes then. Just aim to place everything as accurately as you can.

2 Mix Cerulean and French Ultramarine with white to make the sky colour. Paint around the clouds. French Ultramarine and red with white are used for the cloud shadow; sunlit parts are white with Ochre. Cerulean, Cadmium Yellow and white are used for the land, with more Cerulean for the ditch at the front and left.

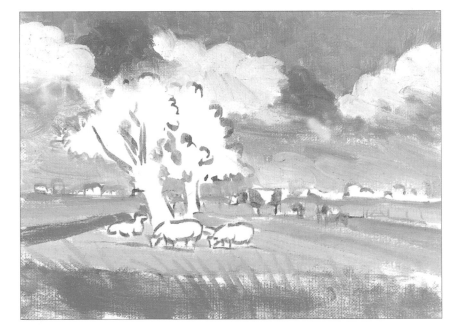

3 Mix French Ultramarine and white for shadows on the animals. Cows' dark patches are French Ultramarine and a little red. Tree trunks are French Ultramarine, Ochre plus a little red. Foliage is French Ultramarine, a little Cadmium Yellow and a little white.

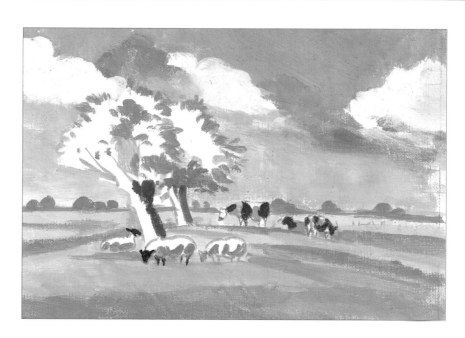

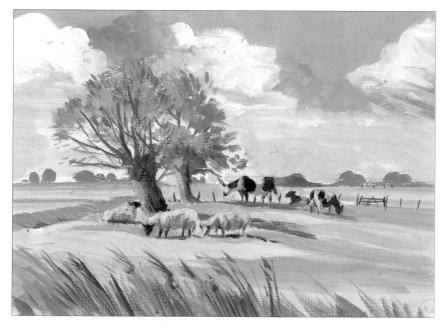

4 Add lights on the foliage: Cadmium Yellow, white and Cerulean. Trunks are Ochre and a touch of white. Branches are French Ultramarine with Ochre plus white. Sheep's wool is Ochre and some white, and cows' highlights are white with a little Ochre. Foreground grass is mixes of French Ultramarine, Ochre and Cadmium Yellow.

You can paint 79

Horses

Horses can also be reduced to the simplest shape possible: a rectangular box. This is a useful device, since it ensures that the legs are placed correctly (at each corner of the box), and the box may be turned to obtain correct angles of the animal's pose.

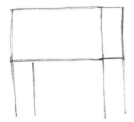

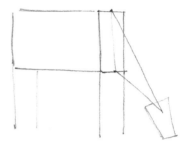

2 *Construct a triangle from the middle of the end of the box for the neck. Add another shorter blunted triangle for the head.*

1 *Simplify the form as a long box shape, with poles at each corner. Use this to construct your horse. The spine is in the middle of the box shape.*

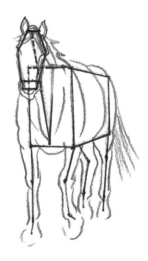

3 *Add the rounded forms on top of the structure. Remember that the front and back legs taper towards the feet, and that there are two joints in the legs.*

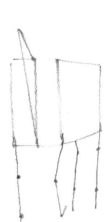

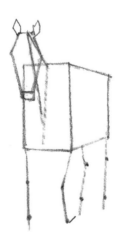

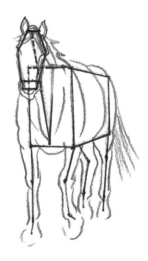

1 *For a horse moving towards you, turn the box to the front, to show its end and a little of its side. Add the legs at each corner.*

2 *Draw a short triangle up from the middle of the end of the box for the neck. Add a coffin shape for the head, and two diamond-shaped ears.*

3 *Add the rounded shape of the body on top. Add the leg and feet shapes, lifting the front right and back left leg.*

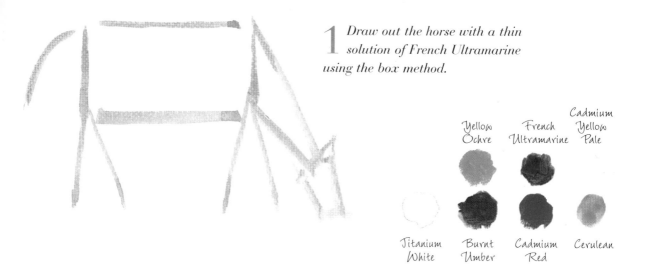

1 *Draw out the horse with a thin solution of French Ultramarine using the box method.*

Yellow Ochre

French Ultramarine

Cadmium Yellow Pale

Titanium White

Burnt Umber

Cadmium Red

Cerulean

2 *Mix brown, French Ultramarine and a touch of white to make a soft dark. Apply to the underside of the horse, the neck and the ears and muzzle. Add red to this mix and a little more white to make the mid-tone. Paint this over the rest of the body, neck and head.*

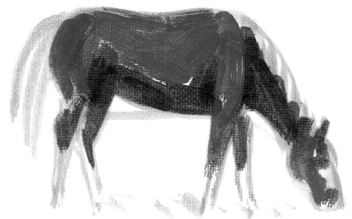

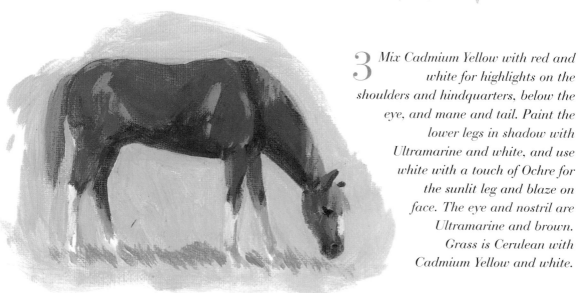

3 *Mix Cadmium Yellow with red and white for highlights on the shoulders and hindquarters, below the eye, and mane and tail. Paint the lower legs in shadow with Ultramarine and white, and use white with a touch of Ochre for the sunlit leg and blaze on face. The eye and nostril are Ultramarine and brown. Grass is Cerulean with Cadmium Yellow and white.*

You can paint 81

AT A GLANCE...

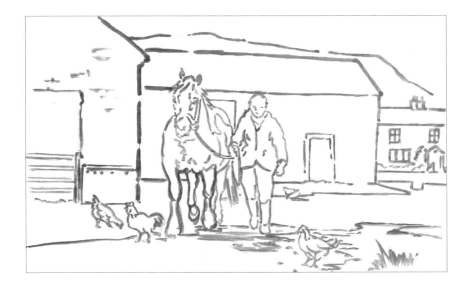

1 *Mark out the composition with a thin solution of French Ultramarine.*

2 *Use French Ultramarine and brown for the doorways. Add more French Ultramarine to the mix for the barn walls, and add Yellow Ochre to this mix for the near wall. The sky is Cerulean and white, the hills are mixes of Yellow Ochre with white and a little Cerulean.*

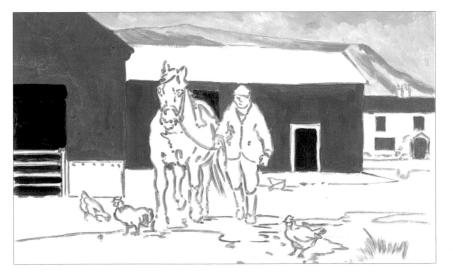

The palette

Titanium
White

Cadmium
Red

Cerulean

French
Ultramarine

Yellow
Ochre

Cadmium
Yellow Pale

Burnt
Umber

3 *Farmhouse wall is French Ultramarine and white, also used for stable lintels and shadows on some chickens (brown and red are used on others). Shadows cast on ground and on horse are Cerulean with a little red and white. Start to add clothes on the man.*

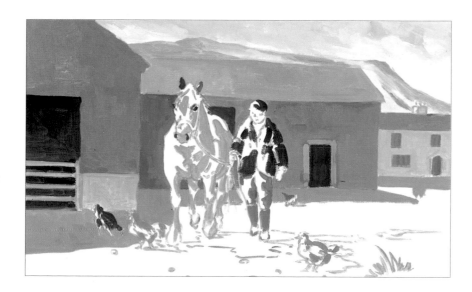

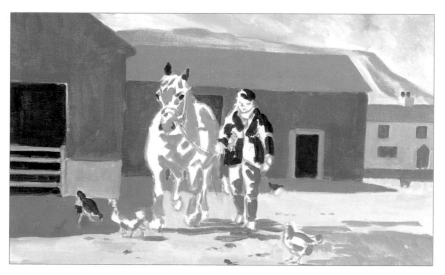

4 *The yard is white with touches of Cadmium Yellow Pale, Yellow Ochre and Red. More Cadmium Yellow Pale is added in the foreground. The grass is Cerulean with Cadmium Yellow Pale and white.*

You can paint 83

5 *Finished picture: Oil sketching paper 29½ x 19 cm (11½ x 7½ in). Highlights on the horse are white with a little Cadmium Yellow Pale to make it creamy. The same mix is painted on the white chickens, with a little Cerulean added to the distant chicken (to make it recede). Red chickens are brown, red and a little white. Man's jacket in the light is red with Yellow Ochre and white, his trousers are Cerulean, French Ultramarine and a little white. The highlight on his boots is Cerulean with Yellow Ochre and white. His face is red, Cadmium Yellow Pale and white, his eyes Cerulean and red with a tiny amount of white. Darker details on grasses are French Ultramarine and Cadmium Yellow Pale.*

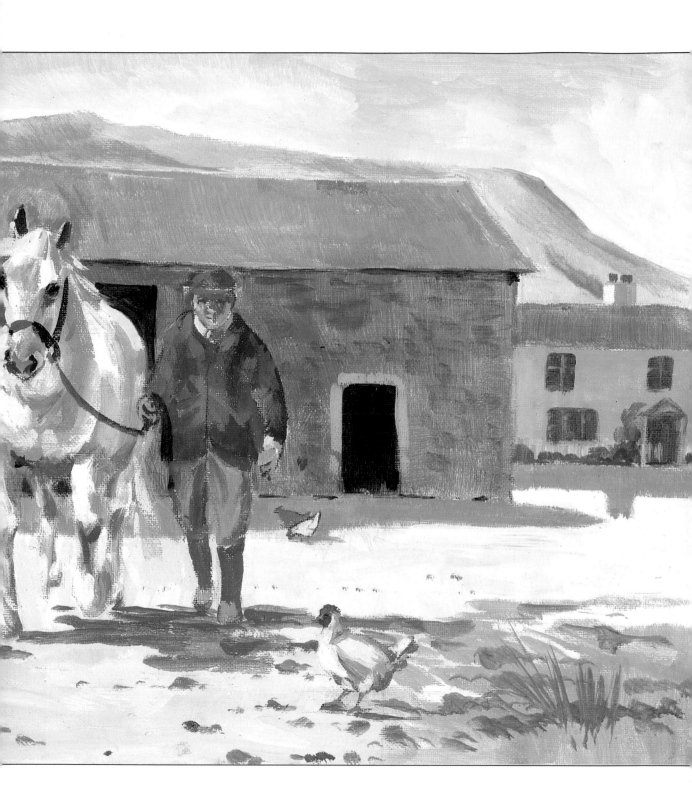

WATER

Water is a fascinating and pleasurable part of the landscape. The secret to painting water successfully is to forget that you are painting it, and concern yourself with looking at the colours and tones you find within it. These are often reflections, which are particularly visible in still, clear water.

Windmill reflection

This windmill makes a good subject for exploring reflections in water. If you have trouble re-drawing the windmill for the reflection, turn the paper upside down. Remember that the windmill is set back from the bank, so its reflection will appear shorter.

If water is slow moving or stagnant, as in canals and ponds, then the shadows are 'dirtier', that is they pick up the reflection plus the colours of the organisms in the water such as algae. This study of a windmill shows how much muddier the colours are when reflected in the water. I used a hog bristle bright and a small, soft brush for this painting.

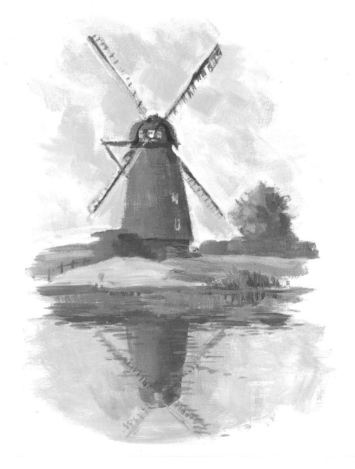

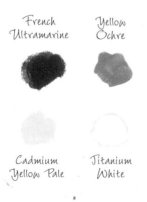

French Ultramarine

Yellow Ochre

Cadmium Yellow Pale

Titanium White

Mountain reflections

Mountains are ideal subjects for reflections. Here I have painted one through the changing seasons. It appears to be mirrored perfectly in the water below. However, watch how dark reflections in the water appear lighter, while light ones appear slightly darker.

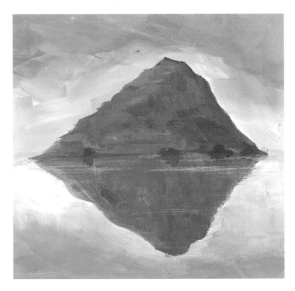

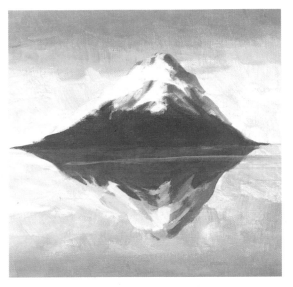

Paint the sky, water then mountain. Add a little white for dark reflections and make any light reflections a little darker. Paint a highlight on the water with yellow and white.

Create the dark areas on the mountain. Paint the snowy peak of the mountain then the reflection. The snow will be reflected slightly darker in the water.

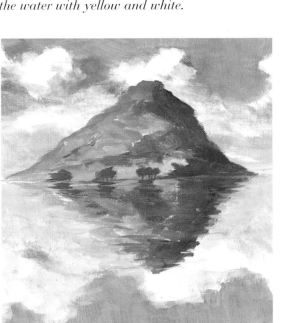

These are shaken reflections caused by the wind. Paint the sky with some clouds, then the water with the same colours (but more evenly) and paint in the mountain. When painting the reflection, break it into a series of steps on the edges by cutting in with short lines of the colour of the water. Do the same with the reflection of the trees on the shore.

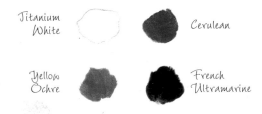

Titanium White Cerulean

Yellow Ochre French Ultramarine

DEMONSTRATION WATERFALL

AT A GLANCE...

 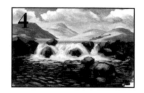

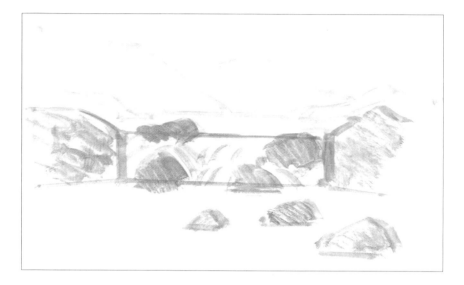

1 *See the waterfall initially as a stair. Mark out in a thin solution of French Ultramarine. Add the rocks to the basic shape.*

2 *Place the darks which are mixes of green and brown with white. At this stage paint the background in. For the sky see p.48. The colours mixed for the background are yellow and Cerulean with white.*

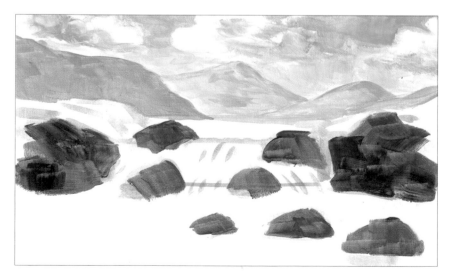

The palette

Titanium White Cerulean Yellow Ochre French Ultramarine Viridian Burnt Umber

3 The shadows on the hills are Cerulean with a little yellow and a touch of white. The highlights are yellow and white with a touch of Cerulean. This is the same mix for all distances, with more white added in the far distance to make them paler.

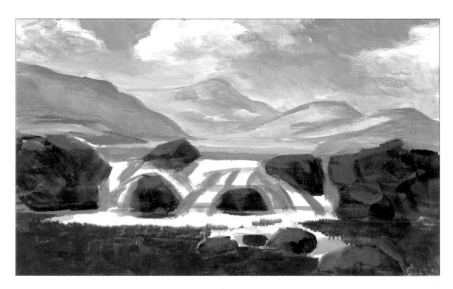

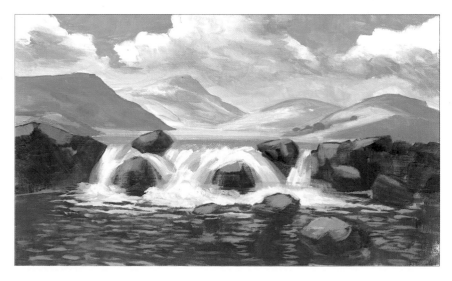

4 *Finished picture:* Oil sketching paper, 26 x 17 cm (10 x 6½ in). Add the lights, applied very thickly. Use white with a little yellow for the water falling and the foam, and yellow, a little white and a small amount of Cerulean for the sunlight on the rocks.

Sea and shoreline

Like other water, the sea reflects the colour of the sky, as well as producing other colours because of its depth. As it recedes, it becomes lighter. Remember to make your sea flat at the horizon, and notice that waves become smaller and closer together the further away they are.

Lines of waves narrowing into the distance.

Broken waves become flatter as they recede.

Waves moving at an angle to the shore. Water often appears as 'tongues' on the beach.

As the tide recedes it causes flatter ripples.

Breaker

Waves are pushed over by the tide or wind into breakers. These are rolls of water breaking into foam, making lace patterns on the shore. They seem impossible to observe as they move rapidly, but watch patiently and you will see what happens. Look for reflections on the wet sand.

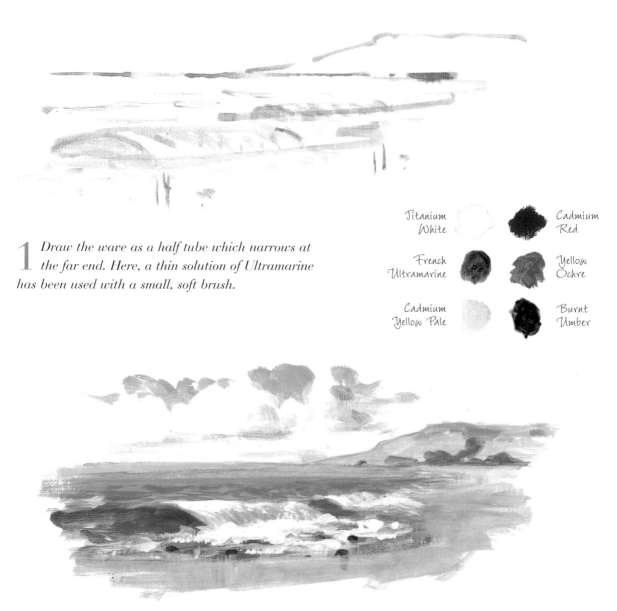

1 *Draw the wave as a half tube which narrows at the far end. Here, a thin solution of Ultramarine has been used with a small, soft brush.*

Titanium White

French Ultramarine

Cadmium Yellow Pale

Cadmium Red

Yellow Ochre

Burnt Umber

2 *Dark waves are Ultramarine and Ochre. The sea and headland are Ultramarine, Cadmium Yellow and a small amount of white (paler near the horizon). Sand and headland are Cadmium Yellow, red and white. Clouds and sea foam are white with a little Ochre, stones Burnt Umber and white. Sky is Ultramarine, white and a little Cadmium Yellow.*

Boats

Boats are an attractive part of a marine landscape. Although their construction appears complicated, they can be built on a simple shape. Here I have used the sort of framework that would be used for a simple rowing boat, but most boats are similar in construction.

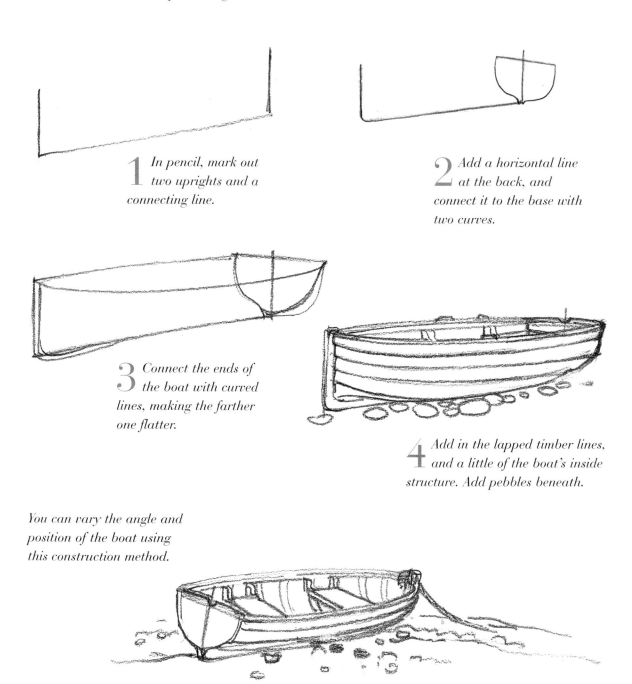

1 In pencil, mark out two uprights and a connecting line.

2 Add a horizontal line at the back, and connect it to the base with two curves.

3 Connect the ends of the boat with curved lines, making the farther one flatter.

4 Add in the lapped timber lines, and a little of the boat's inside structure. Add pebbles beneath.

You can vary the angle and position of the boat using this construction method.

1 Using a solution of brown and a small, soft brush, this trawler is constructed in a similar way to the rowing boat. Add the wheelhouse near the end of the boat.

2 Change to a thicker brush and paint the hull a mix of brown and blue. The wheelhouse and shadow on the hull are blue and white.

French Ultramarine Cadmium Red Titanium White

Yellow Ochre Burnt Umber

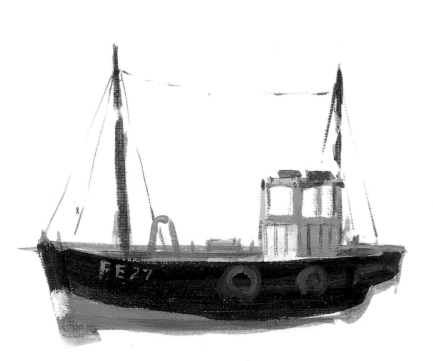

3 The sunlit wheelhouse is white with a touch of yellow, and the rest of the superstructure details are grey (blue with brown and white). Masts are brown with a little blue and white. Red is added to the grey mix for the port light on the wheelhouse.

You can paint 93

DEMONSTRATION HARBOUR SCENE

AT A GLANCE...

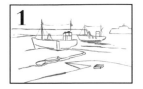

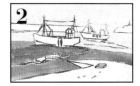

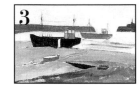

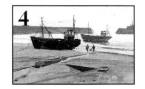

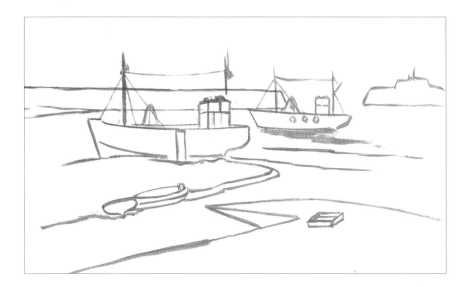

1 *Mark out the picture with a thin solution of Ultramarine. Construct the boats as you did in the previous exercise.*

2 *Mix yellow with white to make cream. Paint the sky and the sea (this colour will become the 'light' on the water). Add a little red to the mix to make a soft orange colour for the foreground.*

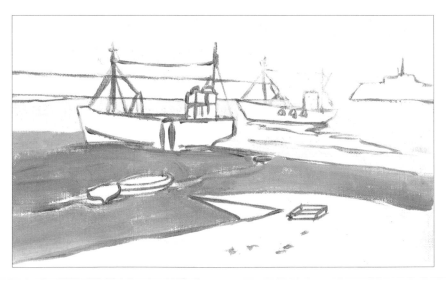

The palette

| Titanium White | Cadmium Yellow Pale | Cadmium Red | Cerulean | French Ultramarine |

3 *Distant piers and wheelhouse shadows are Cerulean mixed with red and a little white. Distant boat and rowing boat shadow are Cerulean and white. Trawler hull is Ultramarine, red and brown plus a little white. Slipway is the sand mix with Cerulean added.*

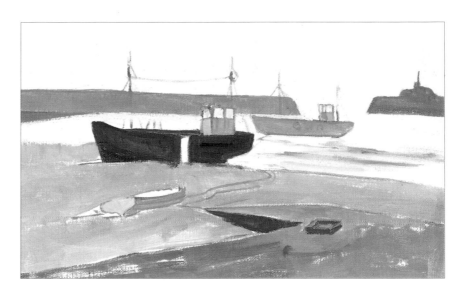

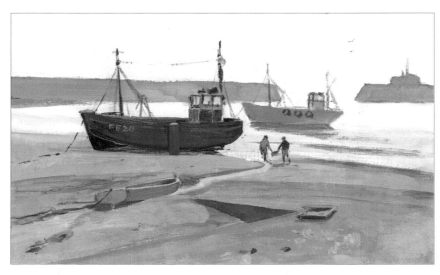

4 *Finished picture: Oil sketching paper, 20 x 14 cm (8 x 5½ in). Wheelhouse is red, yellow, Ultramarine and a little white. Boat details are grey (Ultramarine, red, yellow and white). Figures are painted grey and Cerulean and white, clothes are red and white.*

JARGON BUSTER

Aerial perspective The means of creating a sense of distance in a painting by making the colours paler and more blue/grey as they recede.

Complementary colour Each of the primary colours (red, yellow and blue) has a complementary, formed by mixing the other two. So, red's complementary is a mix of yellow and blue = green. Yellow's complementary is blue mixed with red = purple, and blue's complementary is red mixed with yellow = orange. These colours used next to each other in a picture cause a dynamic visual effect.

Glazing Applying transparent layers of paint over a dry painting to deepen and enrich the colour. Used mainly in the past when pictures were painted in thin layers, it is useful today in unifying a badly coloured painting. Transparent Golden Ochre is sold for this purpose. Apply thinly mixed with retouching varnish. Keep the painting flat until the surface is dry.

Ground The surface on which the painting is made. This may be ready prepared when a painting board or canvas is bought, or can be wood or board with emulsion paint applied in several coats.

Impasto Paint applied thickly so the brush or knife marks are clearly visible.

Linear perspective Achieving a sensation of distance on a picture by the use of objects diminishing in size, and principally of parallel lines which appear to meet on the horizon.

Mahl stick A stick used to support and steady the wrist when painting details in oils. Not much used, it consists of a long bamboo stick with a leather-covered knob which rests on the wet painting whilst you work.

Medium Strictly, the oil paint is the medium, but this term is now used to describe the liquid or gel used to mix with the paint. Linseed oil or turpentine are examples of a medium used with oil paint.

Primer The first layer on a surface being prepared to receive oil paint. It is a material that will not allow the paint to penetrate the surface. It may be gesso or white lead, if buying ready prepared boards or canvas. Otherwise, three coats of household emulsion paint can be used on a surface such as thick cardboard or wood.

Primary colours Red, yellow and blue are the primary colours. Theoretically, all other colours can be mixed from these, but to achieve all the different colours a variety of reds, yellows and blues is required.

Recessive colour Blue is known as a recessive colour, that is, it appears to recede optically. Used in landscape painting, it will create the sensation of recession and is therefore useful for backgrounds. French Ultramarine and Cobalt Blue are particularly useful for this. Red and yellow 'come forward' on a painting, so these colours need to be used carefully if they are included in the distance; they must be light enough in tone not to impose.

Scumbling Working one opaque colour over another, so that the undercolour shows through – this technique gives a lively feel to the painting surface.

Tone Strength of colour, especially when affected by light. A red object receiving light and having shadow will be said to have a lighter tone where the light strikes it, and a darker tone where it is in shadow.